IMAGES
of America

OREGON

D1593986

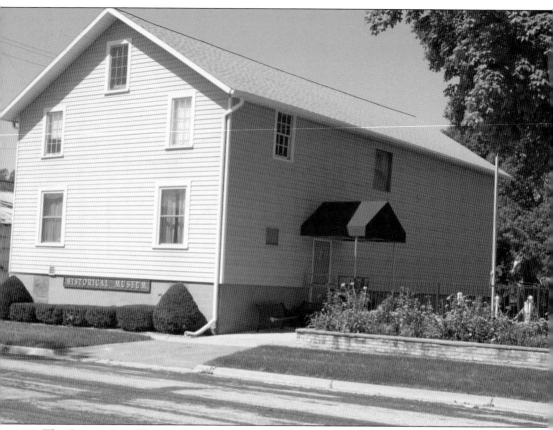

The Oregon Area Historical Society Museum is located at 159 West Lincoln Street. The Oregon Hotel was the first occupant on this site. The hotel was near the railroad depot and was a favorite stopping place for traveling salesmen and stock dealers. The hotel burned down in May 1906. A new building was erected in 1908 and functioned as a farm co-op. In the early 1930s, the Allen Lumber Company assumed ownership of the building and various owners followed. Florice Paulson purchased the building from Fred Chase in 1989 and donated it to the Oregon Area Historical Society for use as a museum. Since the historical society was founded, many volunteers worked countless hours to transform the building into a museum. The members of the society today are grateful to all those volunteers before them who worked so hard to provide a museum and to preserve the local history. (Courtesy of the Oregon Area Historical Society.)

ON THE COVER: Bicycles were very popular at the turn of the 20th century. A group of young Oregon residents gathered on April 24, 1898, on North Main Street for a bicycling excursion. They probably purchased their bicycles at Oregon's Badger Bicycle Company. (Courtesy of the Oregon Area Historical Society.)

IMAGES
of America

OREGON

Oregon Area Historical Society

ARCADIA
PUBLISHING

Copyright © 2017 by Oregon Area Historical Society
ISBN 978-1-4671-2701-1

Published by Arcadia Publishing
Charleston, South Carolina

Printed in the United States of America

Library of Congress Control Number: 2017939256

For all general information, please contact Arcadia Publishing:
Telephone 843-853-2070
Fax 843-853-0044
E-mail sales@arcadiapublishing.com
For customer service and orders:
Toll-Free 1-888-313-2665

Visit us on the Internet at www.arcadiapublishing.com

*Dedicated to all those who had the foresight to preserve
historical documentation and photographs of the Oregon
area for the benefit of current and future generations*

CONTENTS

ACKNOWLEDGMENTS

This book would not have been possible without the efforts of many people. We especially thank Melanie Woodworth for the extensive time and effort she put into coordinating the project. We thank the core group of volunteers consisting of Melanie, Gerald Neath, Ann Morris, Dixie Brown, and JoAnn Swenson for the many hours spent researching photographs and information to recapture the history of Oregon's first 100 years for this book. It was an educational and valuable experience, as we shared and learned from each other about the area's early settlement, the men and women who established the Oregon community, and its early businesses.

We are grateful to the many people who searched through basements, attics, closets, bookshelves, and albums to provide historical family photographs and information for this book. Special thanks go to Rita Madsen Kluever, Betty Madsen Cahoon, Ann Champion Benedict, Ann Richardson Morris, Kay Curless Collins, Marlys Nettesheim, Phil Peterson, Naomi Rockwell, Pat Anderson Wilkening, Dennis Erfurth, LaDonna Smith, Patty Kexel, Lynda and Dennis Farrar, the Sam Ace family, and the Kinney family of Fitchburg. Their contributions to the book are deeply appreciated. We also want to thank Arcadia Publishing for partnering with the Oregon Area Historical Society to make this publication project a reality.

All images are from the Oregon Area Historical Society, unless noted otherwise.

INTRODUCTION

The village of Oregon is located in south central Wisconsin, a few miles south of Wisconsin's capital of Madison. Oregon has a proud and unique history. Through photographs and words, the Oregon Area Historical Society is pleased to share the stories of the people, places, and events of Oregon's early history. You are invited on a historical journey through the decades from the 1840s, when the first settlers arrived from the eastern states, through the World War II years of the 1940s.

During the last glacial age, the surrounding area of Oregon was located at the end of what is known as the Johnstown Moraine. When the moraine started to retreat about 20,000 years ago, its ridge of ice moved back and forth, forming the distinctive topographic features that surround us today. About 7,000 years ago, the climate began to stabilize. Native Americans began to populate the area as prairies became established and wildlife became more abundant.

Prior to its settlement by New England Yankees, the area was inhabited by Native Americans of the Ho-Chunk Nation (also known as the Winnebagos). S.W. Graves writes in his article about the area of Rutland, located just south of Oregon, "When I first came into town, the Indians were very numerous. They would often pitch their tents near some spring and hunt deer for weeks and then move on."

The southern Wisconsin frontier first opened to permanent settlement in the late 1830s and early 1840s. Settlement was encouraged by the end of the Black Hawk War in 1832. Further development occurred with the opening of the east-west lead mining trails that passed through the area from the southwestern region of the territory.

The first settlement in the area is attributed to Bartley Runey. He built a log cabin in 1841 just south of the present-day village of Oregon at the junction of what are currently Union and Rome Corners Roads. Runey operated a tavern and inn known as Pioneer's Hotel. Its location along the Old Lead Trail soon made it a favorite stopping place for teamsters hauling lead from Mineral Point to Milwaukee. The inn also served as temporary lodging for settlers until they could establish their own homes. Runey was accidentally killed in 1858 when his wagon overturned in a team runaway on the present Nine Springs Hill between Oregon and Madison. For years, it was known as Break Neck Hill.

At the time of its settlement, the land in this area was described as slightly undulating. The soil was especially adaptable for agricultural purposes. The vegetation was primarily oak savanna consisting of burr oak, red oak, and white oak trees with open expanses of prairie and marsh. Many springs and creeks in the area provided a valuable source of water.

In 1842, Robert Thomson was the first settler in what was to become the village of Oregon. He built a log cabin along the banks of a creek near what is now Janesville Street and South Perry Parkway. A large Victorian farmhouse was built on the property in 1889 by Robert's nephew George Thomson. It has since been moved to a site outside of the village.

In 1843, C.P. Mosely built a part-log, part-frame house and tavern near the site of the present water tower on Janesville Street. It served as a religious and business meeting place for the settlers as well as an inn. On April 26, 1845, a meeting was held there for the purpose of organizing a church, which was known as the First Congregational Church of Fairfield. In November 1846, it was changed and became the nucleus of the First Presbyterian Church. The Mosely property was later purchased by I.M. Bennet and operated as a country general store and tavern.

The political boundaries changed rapidly during the early years of settlement. A large area of land was organized on February 2, 1846, as the town of Rome. It was named after Rome in Oneida County, New York, at the suggestion of J.N. Ames. The town of Rome originally encompassed what are now the towns of Oregon and Dunn and the city of Fitchburg.

In 1847, Rosel Babitt circulated a petition for the separate formation of the town of Oregon. At the same time, the town of Fitchburg (originally called town of Greenfield) was separately organized. With the formation of the town of Oregon and the town of Fitchburg into separate entities, the town of Rome was changed to include the present towns of Dunn and Pleasant Springs. From this, the town of Dunn was later separately organized. The remaining town's name was changed to Pleasant Springs and the aforementioned town of Rome ceased to exist.

Meanwhile, a settlement of residences and local businesses sprung up around the crossroads of the lead trails from Mineral Point to Milwaukee and Racine and the mail route between Janesville and Madison. It became familiarly known as Rome Corners.

When the railroad came to this area in 1864, it named the depot Oregon. Many residents continued to refer to the settlement as Rome Corners. Confusion over the settlement's name continued until 1883, when the village of Oregon was officially incorporated. At the time, the village had 581 inhabitants and a yearly budget of $150. Manuel Wolfe was the first village president.

The village of Oregon was originally an agricultural community. Prior to 1880, the village had four harness-makers, seven general merchandise stores, three furniture stores, three millinery and dressmaking shops, three meat markets, and four boot and shoe shops. There was also a tailoring shop, blacksmith shop, drugstore, flour and feed store, and hardware store. Businesses continued to expand to include a billiard hall, hotels, a printing office, barbershops, banks, and a bakery.

J.B. Munger made a superior quality of white brick in his brickyard located on the village's south side. Many buildings erected in the village's downtown area in the 1890s were built from brick from his brickyard. The bicycle factory Badger Bicycle Works was built around 1890. While the factory was being built, a source of water was discovered on the property. The factory had a pump and, in a limited way, furnished water to a few businesses and residences nearby. This discovery was advantageous for future water service and fire protection. The village purchased the water supply, and in 1898, village residents voted for a $6,000 bond to meet the expenses of a pump house and water tower.

Until the early 1940s, Oregon-area residents relied on the village as the center of economic and social life. World War II and its aftermath were to bring significant changes. The village was no longer just an agricultural community. With better roadways and methods of transportation, it became a bedroom community, where commuters were now relying more on the Madison area to provide employment as well as social opportunities. Despite the changing makeup of the village, Oregon has retained a unique identity sustained by a strong sense of community spirit.

One

EARLY HISTORY

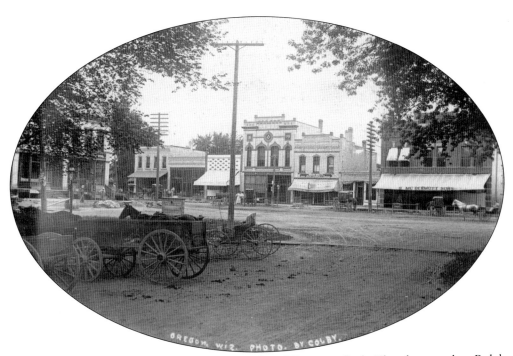

This 1900 view of downtown Oregon is across from Waterman Park. The photographer, Ralph Colby, captured many images of Oregon and its residents in the early years.

Robert Thomson settled here in 1842. He purchased 46 acres from the government, building a log cabin on the bank of what is now Thomson's Creek, near Janesville Street and South Perry Parkway. He died in 1882, leaving 42 acres to his daughters, who in turn sold it to Robert's nephew George Thomson and his wife, Ella.

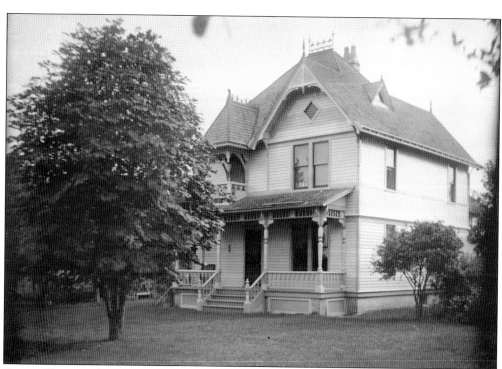

George Thomson (a carpenter) built a larger home at the same location in 1899. He and his wife, Ella, farmed the land and lived there until George died in 1927. Ella remained there until she died in 1938. The house was built during a time when Gingerbread architecture was popular, so George added scrollwork and Victorian decorative features.

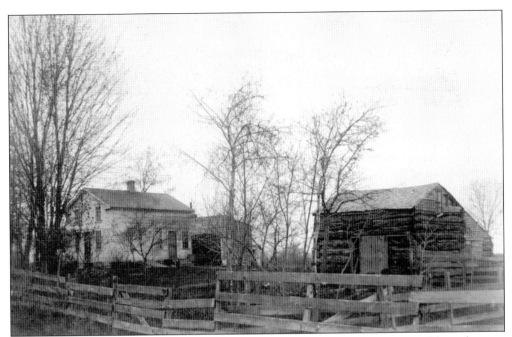

Robert Palmer Main came to Wisconsin in a covered wagon in 1845. His original log cabin was located about three miles south of the village. He and his wife, Cordelia Dakin Main, were both schoolteachers. Their home was a meeting place for pioneers.

Robert Palmer Main was a justice of the peace and was also elected to the Wisconsin Assembly. He made weekly trips to the legislature in Madison on horseback accompanied by his young son Edwin Dakin.

11

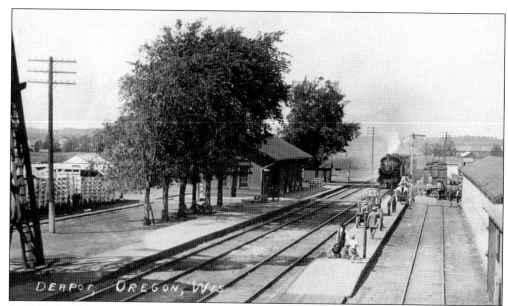

In 1864, the Beloit & Madison Railroad (later the Chicago & North Western) extended the line through the village, giving Oregon an advantage as a business center and bypassing the nearby settlements of Union, Rutland, Story, Oak Hall, and Lake View. Oregon became an important nucleus of trade, shipping livestock and grain to the Chicago market. It functioned for almost 100 years from the mid-1860s to early 1960s.

Patrick J. Landers was foreman on the railroad section gang in 1910. His crew pictured here includes, from left to right, (first row) unidentified, Leroy Johnson, and unidentified; (second row) Guy Solomon Johnson, Ralph Johnson, and Isaac ?

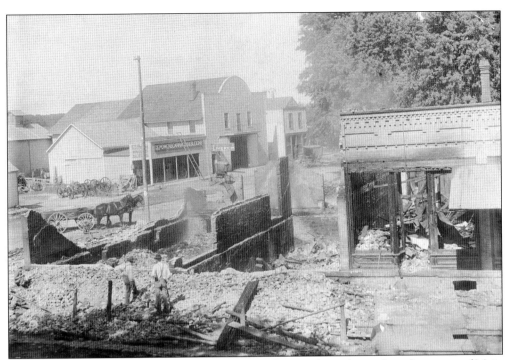

The Netherwood Building, built by Charles W. Netherwood, was located on the corner of Main and Jefferson Streets. The second story was used as a meeting hall for fraternal and literary groups, as well as social functions. After the building burned down in 1873, Netherwood rebuilt it. Fire destroyed the building again in June 1898 (shown below). Netherwood rebuilt again in 1899, and this time, it was appropriately called the Phoenix Building.

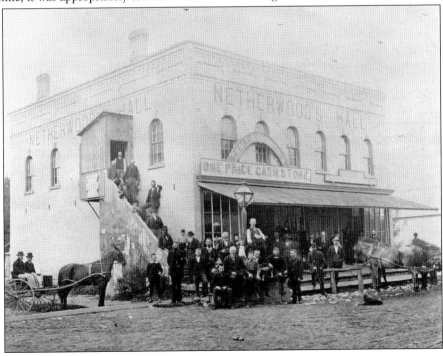

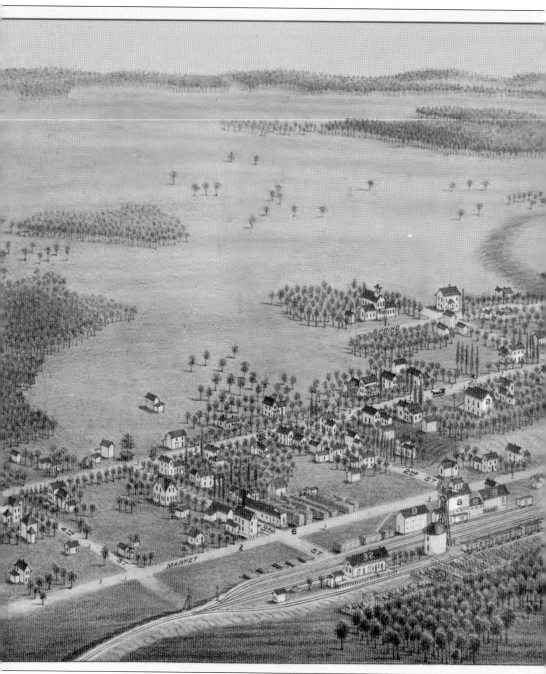

In 1880, Oregon was a community of about 580 persons, with a thriving commercial district. The only named roadways were North Main, South Main, Janesville (shown as Ganesville on map), West,

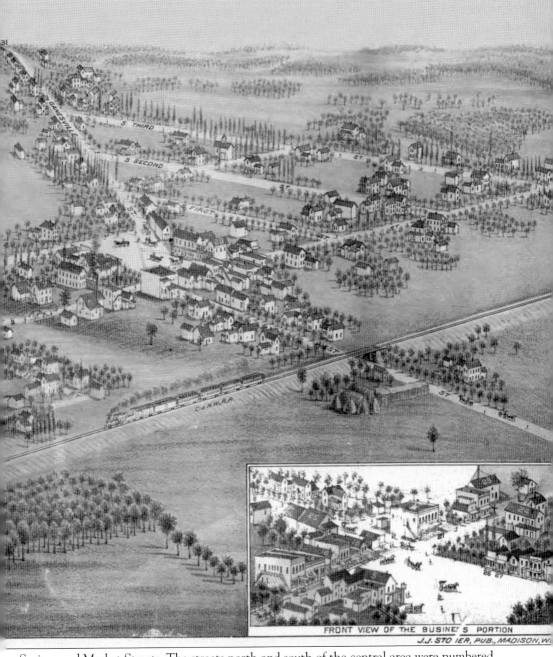

Spring, and Market Streets. The streets north and south of the central area were numbered.

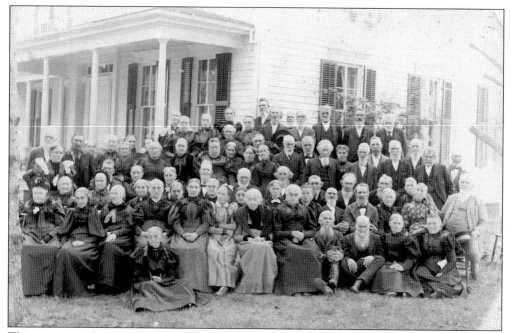

This pioneer gathering from September 25, 1897, was held at the W.L. Ames farm, just south of Oregon on Union Road. About 75 people attended, and the average age was 73. Ruany McKebby and Cordelia Main were the oldest ones present, both 85 years old. The first "Old Settlers" picnic took place in 1875.

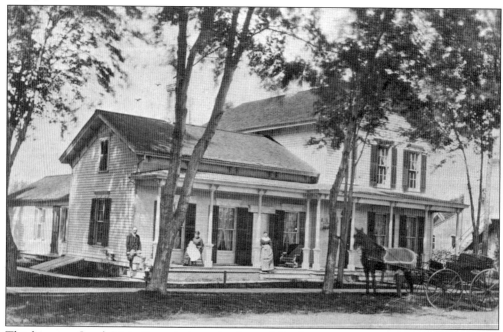

This home on South Main Street belonged to James J. Lindsay, a prominent Oregon businessman. He was born in 1844 in Lancaster County, Pennsylvania, where he learned the trade of a machinist. Lindsay served in the Civil War and came west in 1865. He was engaged in farming in Fitchburg and later moved to the village. He married Mary J. Terwilliger in 1867.

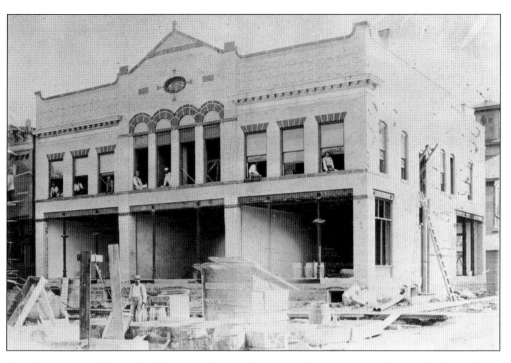

The Netherwood Block building on the south side of the square (on Janesville Street) was constructed in 1898. Workers on the project were Italian workmen returning from Madison on their way to Chicago. The cream brick used was most likely from Munger's brickyard located on the south side of the village. Many businesses were located here over the years, including the *Oregon Observer* office, the post office, the library, Laughlin's Jewelry (later Wischoff's jewelry store), a barbershop, and a meat market. The second floor housed Martin's cigar factory and was also home to a fraternal organization the Modern Woodmen.

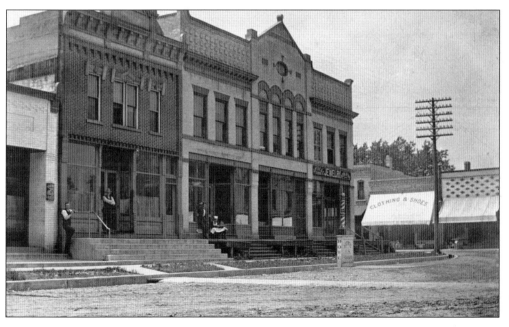

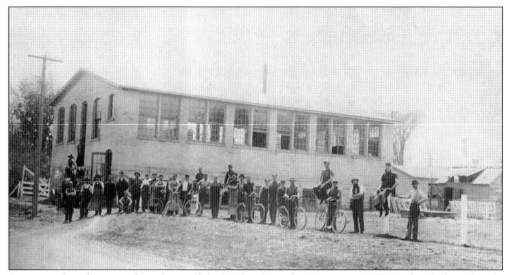

A group of workers stands in front of the Badger Bicycle Company. In 1898, the Badger Bicycle Company produced 1,000 bicycles of two grades—one for $35 and another for $50. The company was in operation from about 1890 to 1900.

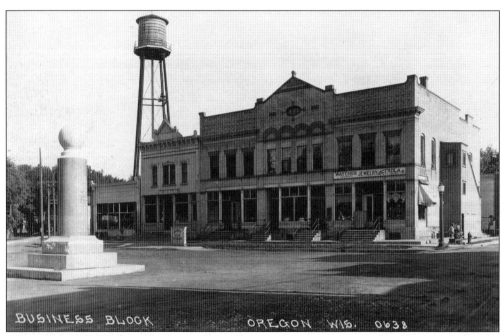

When the bicycle factory was built, a well was discovered on the property. The village purchased the water supply, and the village residents voted for a $6,000 bond to meet the expenses of a pump house and water tower. In 1899, the water tower and pump house were erected by Fairbanks Morse and Co. of Beloit. It originally had a tower with a wooden tank that had a 15,000-gallon capacity.

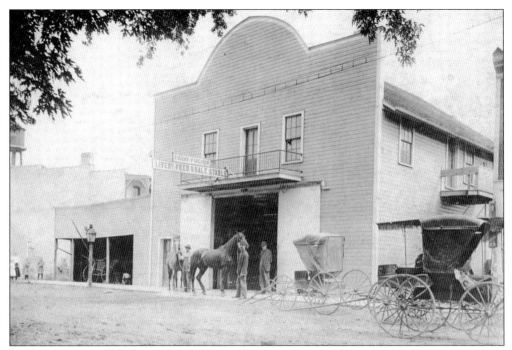

This early livery stable located on Jefferson Street was operated by Fisher and Barton and later purchased by Frank Fincher. Later, when automobiles came into use, a Ford garage and a salesroom were added to the west side.

The "Hitching Park" space was established in 1906 when the hitching posts in front of the stores were removed. A great deal of animosity was created between merchants and rural customers when the village proposed to dedicate a place for hitching teams. The townsfolk preferred this plan, which was cleaner as well as safer, since horses sometimes nipped people.

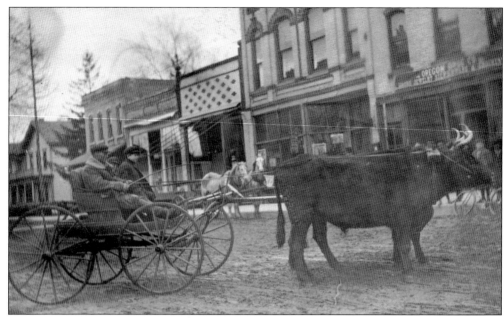

This 1911 photograph shows Antone Nelson driving an oxcart in Oregon, with Dowell (middle) and Mernin Richards (sons of Roy and Ethel Richards). Prior to the arrival of the railroad, early pioneers often made long journeys with oxen to Milwaukee or Galena for supplies.

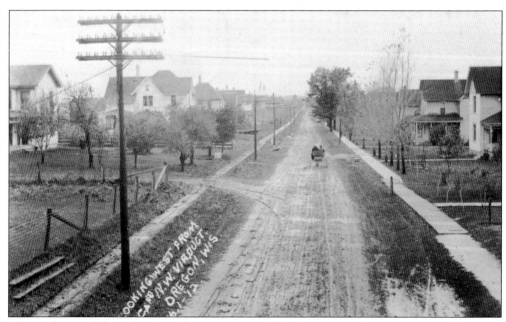

The road west of the railroad viaduct was once called Copenhagen Street because of the large Danish population living in the area. It was here in "No-Man's Land" in 1923 that Elmer and Adelbert Peterson and Christopher and Leon "Jack" Johnson constructed the first concrete street in Oregon. They laid 50 feet a day, using a hand mixer. This road is now named Jefferson Street/ County Highway CC.

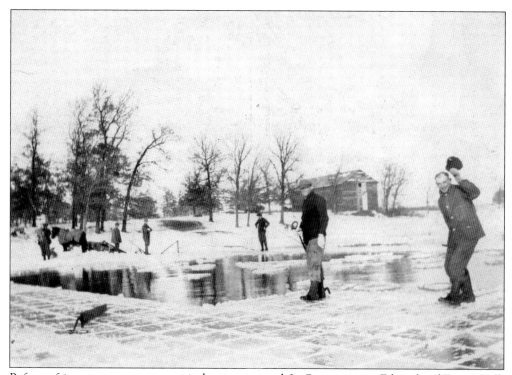

Before refrigerators were common, iceboxes were used. In Oregon, it was Edward and Ernest Culb who cut ice during the winter months from Lake Harriet, just west of Oregon. The ice was stored in an icehouse near the lake, where the blocks were packed in sawdust and straw. The village customers would display a sign indicating the size block of ice they needed that day. The ice wagon would come and an iceman cut the ice to the size requested by the customer.

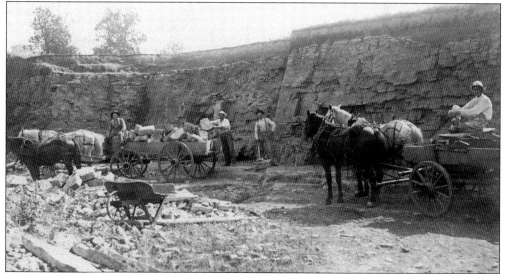

In 1905, the village purchased a quarry for $300 and a stone crusher for $950, in order to keep the streets in good condition. The quarry was located in back of the hill now known as Madsen Circle. Depicted at the quarry site are workers William "Bill" Kelley lifting rock and William L. Clark driving the wagon.

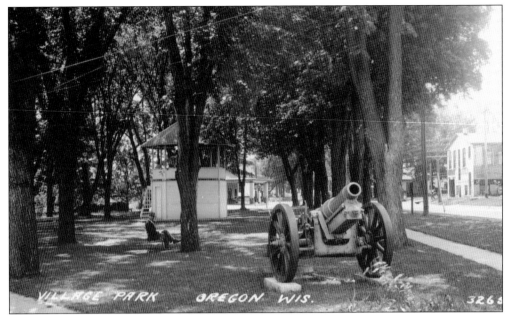

This 1915 photograph depicts the wooded area directly across from the pump house, now known as Waterman Park. At that time, there were many more trees. Several were sacrificed for additional parking. The gazebo was eventually replaced with a larger band shell for the Oregon Community Band, and the cannon was relocated. The man sitting on the bench is Gilbert Gilbertson.

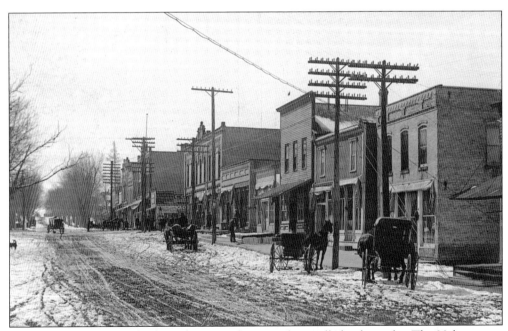

An early, wintry view of the downtown area shows newly installed utility poles. The 20th century brought many changes. In Oregon, village residents were beginning to enjoy services of electricity, telegraph, and telephones.

Two

AGRICULTURE

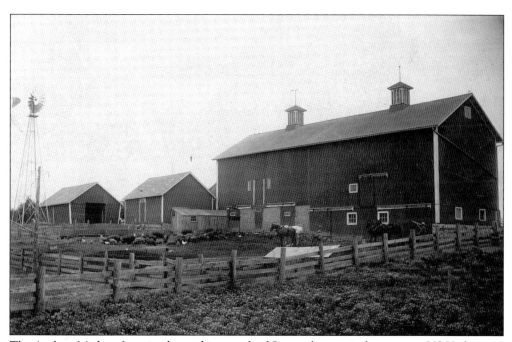

The Andrew Madsen farm was located just south of Oregon between what are now US Highway 14 and State Highway 138. Farming was important in the area. The first settlers found favorable soil and climate for raising corn, wheat, hay, and later, tobacco. They raised cattle, pigs, chickens and sheep. The arrival of the railroad in 1864 gave the farmers a shipping point for grain and livestock, creating broader markets in Milwaukee and Chicago. (Courtesy of Rita Madsen Kluever.)

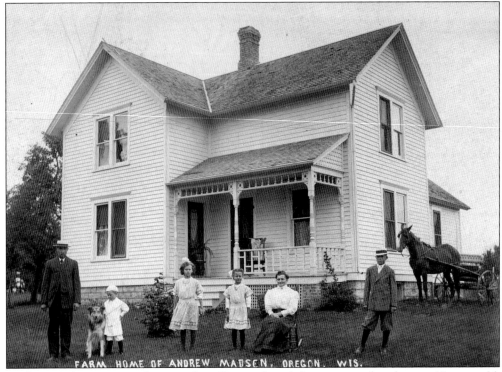

Andrew Madsen came to America from Denmark with his parents when he was 12 years old. His family first settled in Fulton, and they later moved to Oregon. In 1894, he married Hannah Nelson. Andrew was a farmer but also served on the county board and was president of the village. The Madsen family is shown in front of their farmhouse. From left to right are Andrew, Forest, Violet, Lucille, Hannah, and Homer. (Courtesy of Rita Madsen Kluever.)

The Kelley farm was in the town of Oregon on Netherwood Road. William Clark, Catharine (Elliott) Clark Kelley, Blanche Clark, and William T. Kelley are pictured from left to right in their front yard. The farmhouse was the center of the homemaker's domestic activities, as well as entertainment for the family and neighbors. In addition to keeping the family fed and clothed, the women also helped with the livestock and crops.

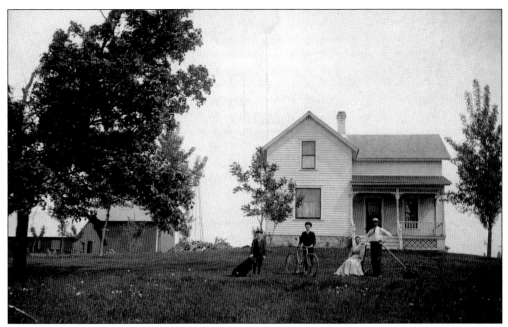

The Nels Peterson farm was located west of Oregon on Highway CC. Shown in front of the farmhouse are, from left to right, sons Arba and Walter and parents Minnie and Nels. Nels was born in Denmark, immigrated to America in 1884, and married Minnie Madsen in 1895. Arba's son Philip L. Peterson and his wife, Carol DuPont Peterson, have continued to live in the area, on a farm on Highway CC.

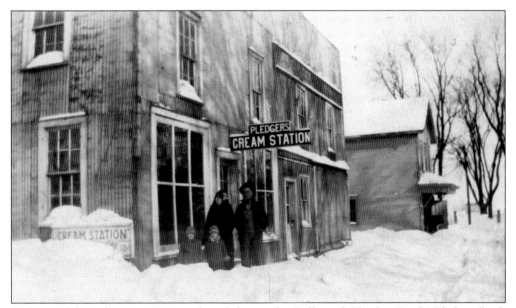

In front of their shop in 1928 are, from left to right, Belle and Charles "Buck" Pledger (back row) and their niece, Audrey, and daughter, Vera, standing in front of them. The Pledger Cream Station was located on Park Street and was torn down to make room for the new village hall. Buck continued his business in a small building next to the family home on North Main Street.

In the 1920s, milk production increased with 14 dairy farms in Oregon. Some of these farms began bottling milk and making butter and cheese. Initially, delivery service to residents was by dipper and pail. Dairies were operated by Waterman/Spaulding, Gefke's, Perry Netherwood Pledgers, Martha Owen, John Hooper, Clarence Johnson, Andrew Christensen, and Thomas Hobbs. Perry Netherwood started his dairy farm at 276 North Main Street in 1910. His two faithful white horses, Tom and Jerry, delivered milk door-to-door. In the 1920s, Dolly replaced Tom and Jerry. Glass bottles replaced the pail and dipper. In 1932–1936, Martha Owen and several children took over the farm. Sons Tom and John delivered milk and cream in their wagon before school, while sons Edward and Robert were in charge of the farming and dairy operation.

The Park Lane Dairy Farm, located on Syene Road in the town of Fitchburg, was owned by Ole and Elsie Dale. Their sons Oscar and Elmer Dale bottled their milk. In the 1920s and 1930s, they delivered to Park Street and the Greenbush neighborhood in Madison. They also raised many acres of tobacco. (Courtesy of Ann Richardson Morris.)

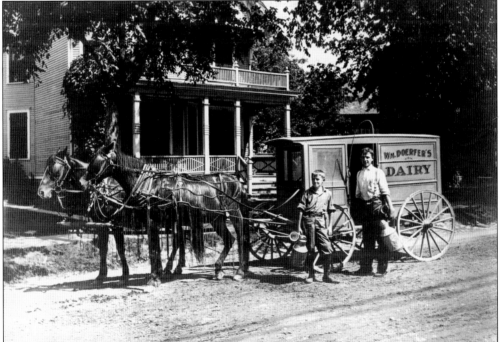

Doerfer Dairy Farm was located west of the village of Oregon on Fish Hatchery Road. The Doerfers bottled and delivered milk to the surrounding areas. Pictured are the Doerfer brothers, Robert and Lloyd, with their horses and milk cart. Dairies like this were a family business, and all members of the family helped out with the chores.

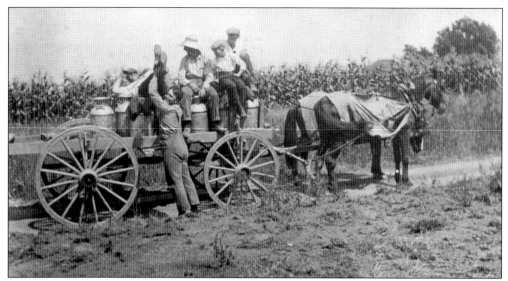

Farmers in the Oregon area brought their milk cans to various dairies. They hauled their cans in horse-drawn wagons. The children often had fun riding along to town. In the late 1920s, milk was delivered to homes. Milk sold for 5¢ a pint and 10¢ a quart. A customer bought a sheet of tickets for $1 and then placed an order by putting a ticket in a bottle for the milkman.

Robert Gefke and his sons Maxwell, Stanley, and Robert Jr. started the Gefke Dairy Farm in1928. Their Oregon dairy was located on their farm just south of the Oregon village. Robert and Stanley delivered milk to half of the village, and the Netherwood Dairy supplied the other half of the village. The Gefke operation remained in business until 1951.

Percy Neath and his son Eldon are using a pushcart to bring the cans of milk from the barn to the milk house. This is where the milk is cooled before taking it to the dairy or cheese factory. At that time, the milk house was usually near a water supply such as a spring, windmill, or well. (Courtesy of Gerald Neath.)

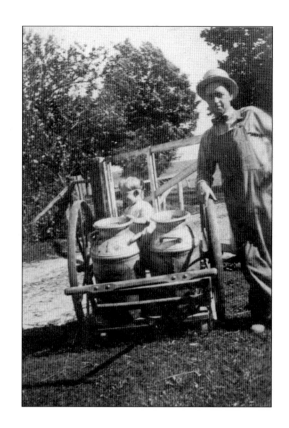

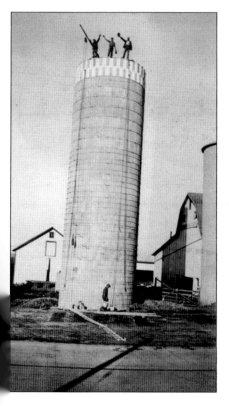

Cement silos were being built in the 1930s for silage storage for cattle. Roy Christensen was one of five sons of Danish immigrants Hans Peter Christensen and his wife, Anna. Roy began working on a crew to build these silos in the area. The picture shows Roy on the top of the silo with some of the crewmen. (Courtesy of Marlys Christensen Nettesheim.)

Tobacco seeds are very susceptible to fungus and disease. To eliminate these problems, tobacco beds are steamed when the seeds are sewn. Pictured is the type of machine use for this purpose in the Oregon area.

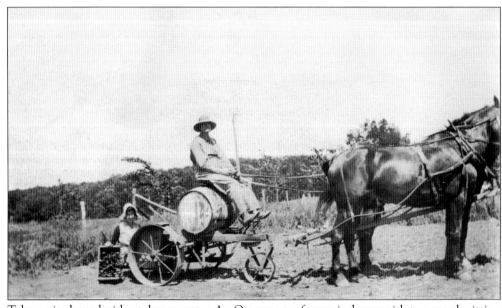

Tobacco is planted with a tobacco setter. An Oregon-area farmer is shown with two people sitting on the back and individually planting each tobacco plant. A barrel of water is used to give a shot of water to each plant. Plants are pulled from a tobacco bed and placed in boxes and planted as soon as possible.

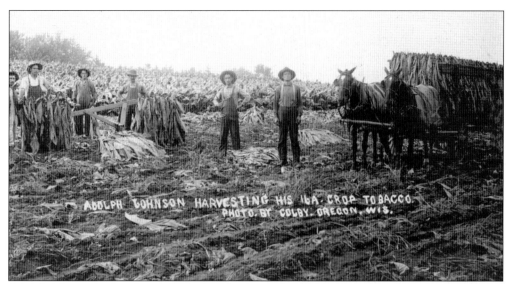

Adolph Johnson had a tobacco farm in Rutland. Farmers surrounding the village of Oregon found that growing tobacco proved to be a good cash crop. The tobacco grown in the Oregon area was, and still is, used mostly for chewing tobacco.

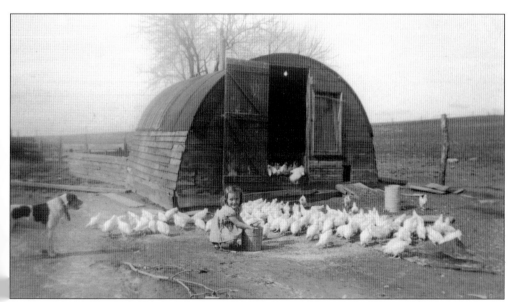

Most farmers raised chickens for eggs and food. Pictured is Marlys Christensen feeding the chickens. The Roy and Clarice Christensen farm is located on Lincoln Road, west of the village of Oregon. (Courtesy of Marlys Christensen Nettesheim.)

31

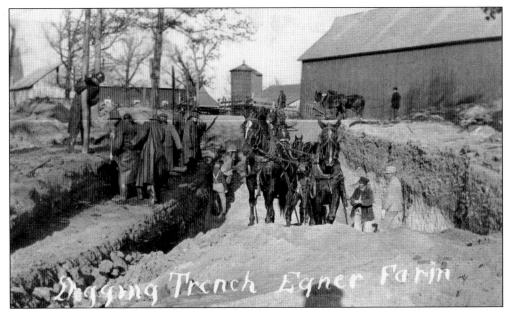

In 1914, hoof-and-mouth disease was taking a toll on area farms. The disease source was sheep brought in from the Chicago Stockyards. Area farms impacted included the Ole Egner farm (Phil Peterson farm), where 110 head of cattle and 70 hogs had to be slaughtered and buried to contain the disease. Many other farms in the area suffered similar losses of farm animals. Crews of local people were hired to dig trenches to bury the infected animals.

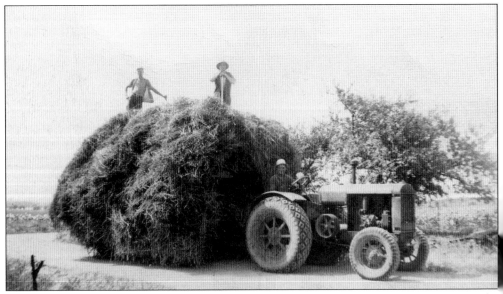

Farmers brought the loose hay to the barn on a wagon, where giant hooks took the load to the haymow. Pictured here are Art Lawry on the tractor, with son Ray Lawry and neighbor Sam Ace on top of the load. The Lawry and Ace farms were located in an area called Storytown, which is west of the village of Oregon. (Courtesy of the Sam Ace family.)

William Champion, originally from England, farmed in the Oregon area. Here, he is bringing grain to the Oregon rail station for shipment to Milwaukee or Chicago. (Courtesy of Ann Champion Benedict.)

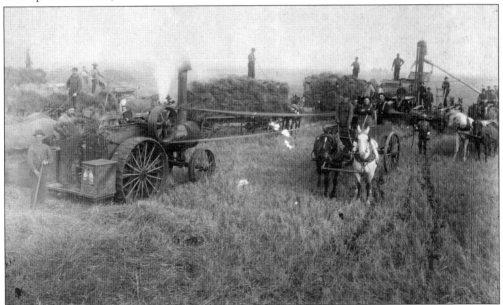

Threshing grain was a neighborhood operation, with everyone helping with the harvest on local farms. One farmer owned the thresher, moving it from one farm to another. Grain was cut, shocked, and put in stacks ready for the threshing machines, which separated grain from straw. Farm women provided meals for everyone. (Courtesy of Philip Peterson.)

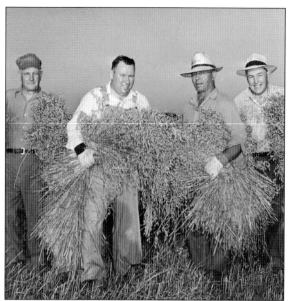

During the World War II years, there was a shortage of workers here at home, especially on the farms at harvesttime. In 1943, two Oregon businessmen, Lester Cotty and R.L. Morrisey, organized local businessmen to help farmers four nights a week. During 1943 and 1944, more than 1,700 acres of grain were shocked and the hay harvest was over 6,000 bales. From left to right, the men in the field are Owen Richards, Cletus Brown, Anton Frederickson, and Wallace Allen (*Capital Times*, Madison, Wisconsin, August 12, 1945).

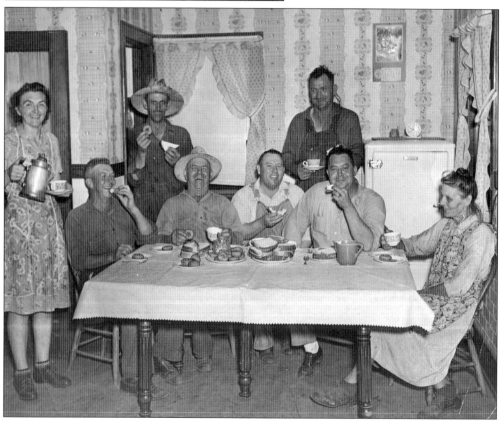

The harvesting helpers are shown taking a break at the Jones farm. Pictured from left to right are (seated) Frank Adams, Anton Frederickson, Cletus Brown, Lester Crotty, and Mrs. Elmer Jones; (standing) Alice Jones, William Jones, and Lawrence Gladem. (*Capital Times,* Madison, Wisconsin, August 12, 1945).

Three

BUSINESS

Oregon businessmen (and a few women) gathered at the dedication of the World War I Monument in 1920. Gold Star mother Cecelia Johnson, mother of William M. Johnson, unveiled the monument at a ceremony attended by hundreds of people.

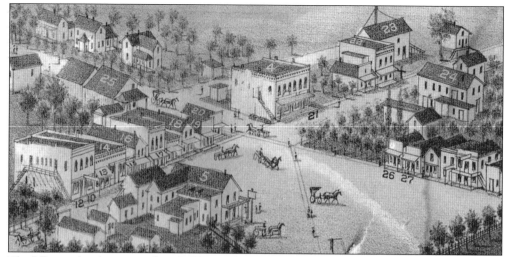

The following businesses are identified by number: 04, Netherwood Hall; 05, Oregon Exchange Hotel (R. Chandler); 10, H.J. Smith (furniture); 12, B.W. Simmons (jeweler); 13, Terwilliger & Lindsay (general merchandise); 14, Isaac Howe (drugs and groceries); 15, J. Hansen (merchant tailor); 16, H.H. Marvin (hardware); 17, C.E. Powers (jewelry and confectionery); 18, B. McDermott (groceries); 19, E.L. Booth (boots and shoes); 20, Johnson & Beckley (millinery and dressmaking); 21, C.W. Netherwood (stationery and insurance); 22, Fox Bros. (druggists); 23, W.H. Myers (machine shop/sawmill); 24, George W. Getts & Son (wagon and carriage works); 25, Fisher & Barton (livery); 26, J.T. Hayes (agricultural implements); and 27, Hayes Bros. (harness shop).

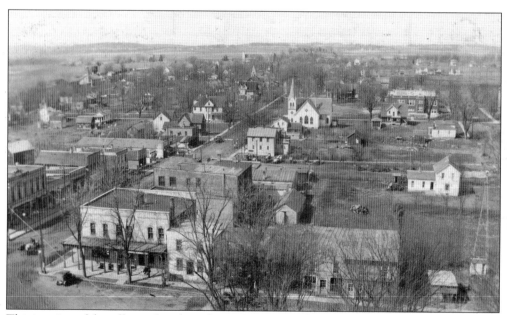

This is a view of the village taken from the water tower in the 1920s. Seen in the left-hand corner is the Portland Hotel. In the background is the steeple of the First Presbyterian Church, and to the right of that is the newly built Red Brick schoolhouse.

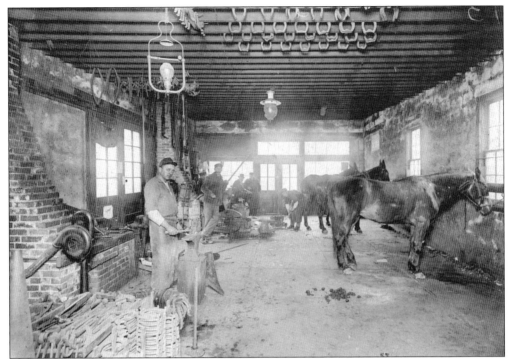

The signage in front of the Sarbacker & Sprague Blacksmith Shop stated that it offered "Practical Horse Shoeing and Repairing." Prior to the automobile, having access to a good blacksmith was a necessity. Illustrated here is a view of the workshop. Later, the demolition of the building provided a wake-up call and an inspiration for Eeda Lumey to organize the Oregon Area Historical Society.

One of the well-known milliners of the village was Cornelia "Nealie" DeJean (left), who established her business in 1902. Over the years, she had several partners. DeJean continued in business until the early 1940s. While in business, she made frequent trips to Milwaukee and Chicago to check out the latest fashions.

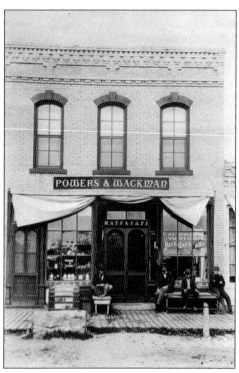

The following is stated in the April 18, 1895, *Oregon Observer Supplement*: "Powers & Wackman, dealers in clothing keep a nice line of gents' furnishing goods, up to date and in proper style; can suit anyone from a bridegroom to a congressman. They have a nice trade and low prices."

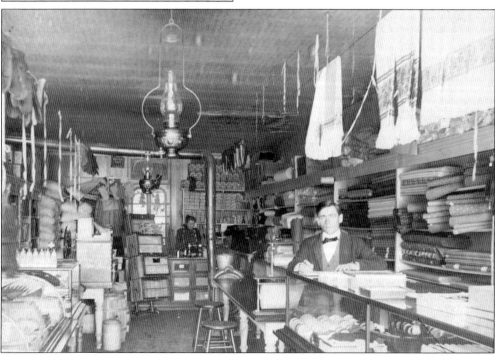

Following his graduation from Oregon High School in1888, Arthur Anderson was employed by M.H. Terwilliger at his mercantile business. Anderson later purchased the business in 1898 and went on to operate it for almost 30 years. For many years, prior to parcel post delivery, he handled the express packages for the Oregon area.

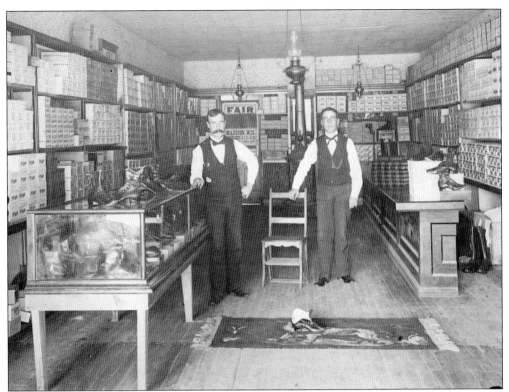

Connor's Dry Goods store was located on the corner of South Main and Jefferson Streets. Tom (left) and John Connor are pictured in their store. It stayed in the Connor family until 1926, when Edward G. Booth and son Gerald purchased the building and opened a furniture store and later with Lindsay, expanded into the funeral business.

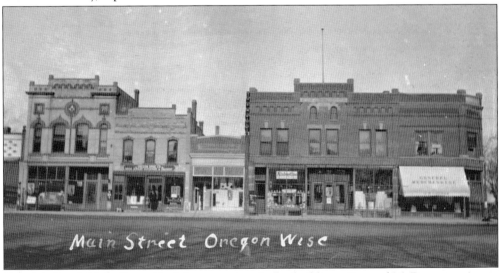

Oregon's South Main Street block has two very similar buildings. Bernard McDermott came to Oregon in 1880 and in 1889 built a two-story, redbrick building for his general store (building second from the right). A few years later, J.P. Connor built a very similar building on the corner lot next to the McDermott building. From a distance, they might be mistaken for one building.

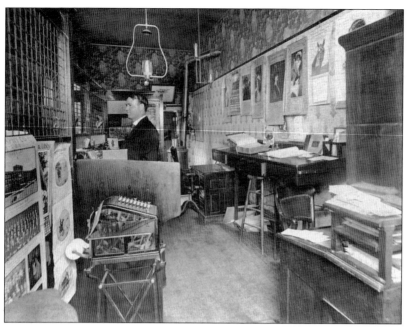

J.F. Litel and his family established the first successful bank in Oregon in 1900. J.F. was the head cashier and is shown in his office at the Bank of Oregon. His sister Mae Litel (who later married Earl Pritchard) worked as a teller.

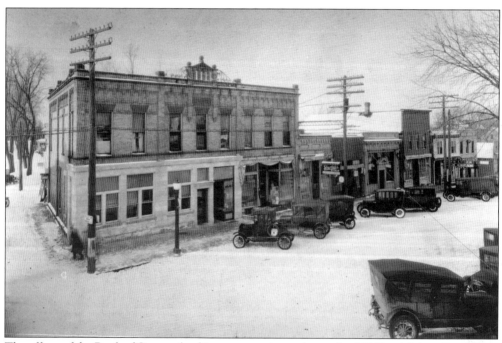

The offices of the Bank of Oregon (and its successors) were located at 101 North Main Street from 1900 until the early 1990s, when a new facility was built in back of the original site. This view from a 1928 photograph shows the bank building and other businesses on North Main Street. (Courtesy of Wisconsin Historical Society No. WHS-43745.)

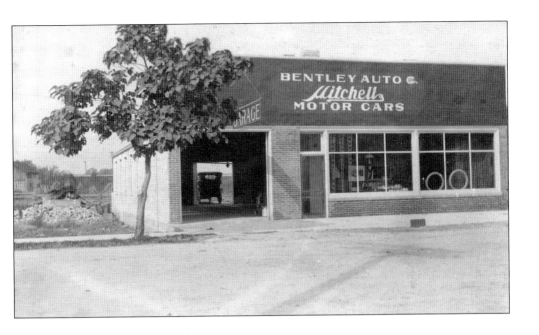

In 1914, W.R. Bentley built a garage in downtown Oregon where he sold Mitchell and Overland motor vehicles. About this same time, other dealerships opened, including F. Jensen Auto Co. (which sold Maxwell automobiles), Fincher Bros. (Fords), and shown below, the Criddle and Kellor Garage (Buicks). Some of the first owners of automobiles in the Oregon area were George Algard, Henry Usher, Harry Hull, H.V. Chappel, and David I. Criddle.

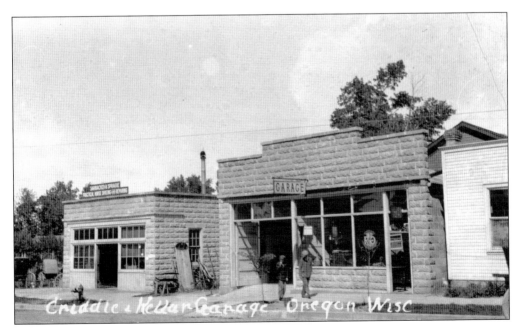

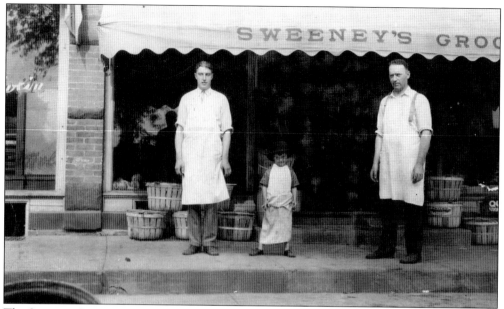

The Sweeney Grocery Store was one of many grocery stores serving the Oregon area. Shown in front of the store are, from left to right, employee Forest "Steve" Madsen, an unidentified child, and owner Eugene Sweeney. Madsen later built his own grocery store, the Home Owned Store, on the site of the opera house.

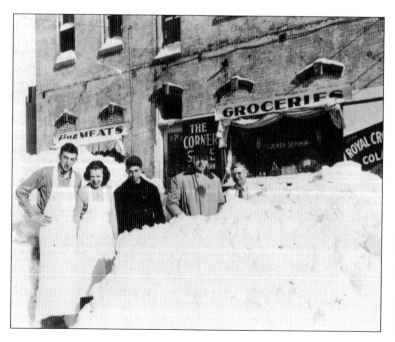

Standing between snowbanks at the Corner Store Grocery in 1946 are, from left to right, Jack Kohlman, Terry Kohlman, Paul Kohlman, Boyce Davis, and John Kohlman. Paul was the owner and operator of the grocery store for many years prior to moving his business to a new location. The building originally was the site of the Grand Central/Portland Hotel.

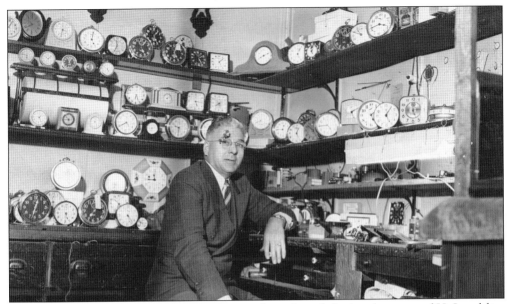

Milton Wischhoff came to Oregon in 1914 and purchased the jewelry store of H. Laughlin. Wischhoff continued in business for the next 51 years. His shop was located for many years in the Netherwood Block Building, after which he moved to a North Main Street location. In the early 20th century, his shop was one of the first to offer Victrolas (record players) for sale.

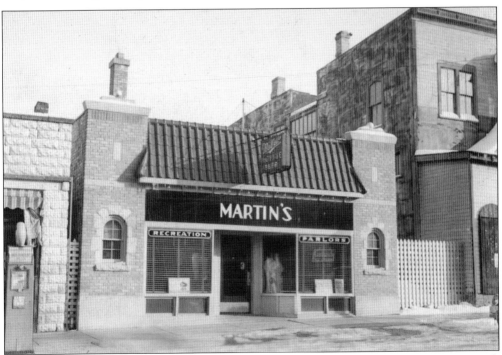

Martin's Recreation Parlor was a favorite stop for many people. The parlor, located on North Main Street, offered bowling and billiards. Martin's advertisements promised a wide variety of treats, including Kennedy's Ice Cream, candy and soft drinks, malted milks (a specialty), and Miller High Life beer.

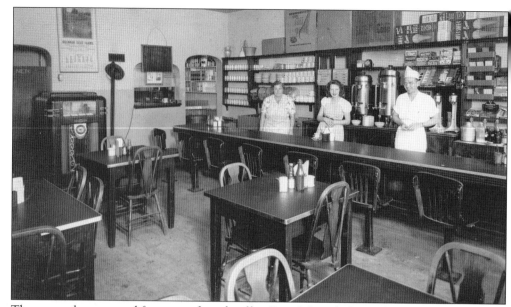

There was always a need for a cup of good coffee. Daisy's Lunch, located on North Main Street across from the Bank of Oregon, filled this need for many years. Pictured are, from left to right, Mabel Fletcher, Mary Alice McCann, and Gordon "Daisy" Booth.

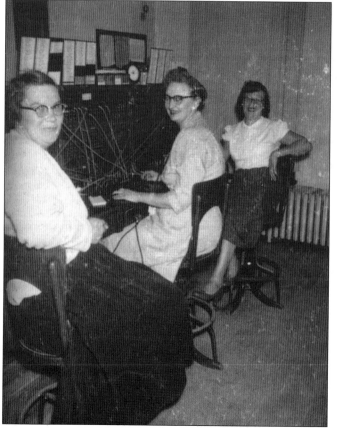

The first telephone service came to the village of Oregon in 1901 and, in 1902, was extended into some of the surrounding rural areas. The Pease brothers, Louis and Roy, continued to develop and expand the service. Addie Barry was the first switchboard operator. Oregon switchboard operators pictured here are Nora Kocovsky Heggestad, Dorothy Tauchen, and Delores Nelson Meehan.

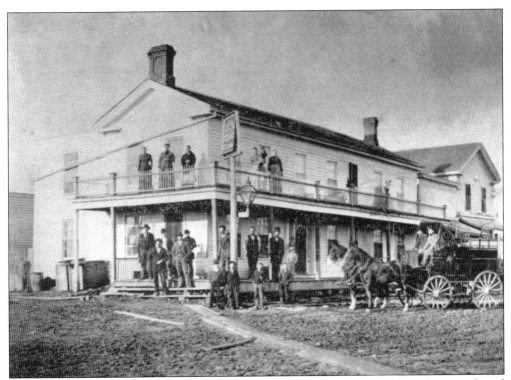

The Exchange Hotel, built in 1845, was the first hotel in Oregon. The hotel was later purchased by R.C. Chandler. The structure was destroyed by fire in 1885. A few years later, the Netherwood Block Building was erected on the site. Another hotel, the Oregon Hotel, located near the train depot was destroyed by fire in May 1906.

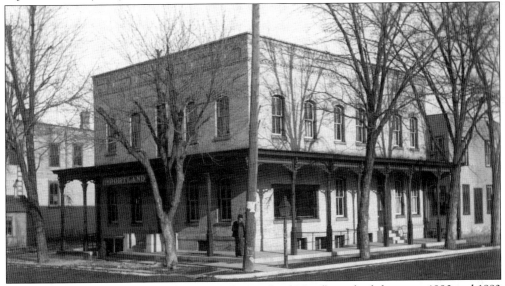

The Grand Central Hotel (later known as the Portland Hotel) was built between 1880 and 1893 on the site of present-day Madsen Park. The *Wisconsin State Journal* in 1898 reported that some considered it to be one of the best hotels in Dane County outside of Madison. After the hotel closed, it was occupied by various businesses, most notably the Corner Store Grocery.

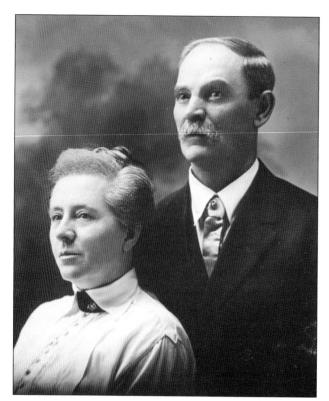

C.P. Lust was the first known dentist to provide services to village residents. In the 1880s, he made trips one day a week to Oregon from his Stoughton office. H.E. Hanan (shown here with his wife, Nora) became apprenticed to Dr. Lust and later opened a full-time office in the village. Among his "reasonable charges" was 25¢ for extractions. Other early well-known dentists were W.E. Ogilvie, G.H. Hippaka, and L.F. Whalen.

Edward Kramer purchased the printing shop and local newspaper from H.D. Hanson in 1910. The *Oregon Observer* had been published since the early 1880s. Kramer would continue to publish the paper until his retirement in 1959. During this time, his wife, Maude, was his partner, collecting and writing many of the local news items. (Courtesy of Oregon Masonic Lodge/Dennis Erfurth.)

Four

CIVIC ORGANIZATIONS

Manuel Wolfe served as the first president of the village of Oregon, serving for one year in 1883. He was born in 1826 in Canada and moved with his parents 10 years later to Richland County, Ohio. He attended and later taught school there. In the spring of 1847, the Wolfe family bought 40 acres in the Oregon area. Manuel married Emma Gifford and settled in Union, Rock County. They relocated to the village of Oregon in 1847.

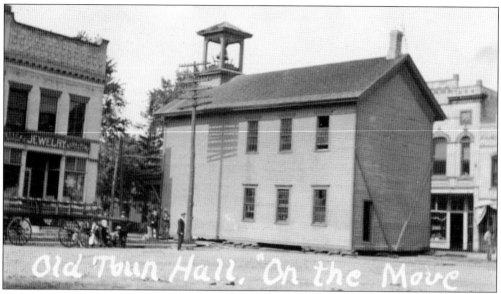

Old Town Hall, "On the Move"

The first town hall was formerly the center section of a two-story school building erected in 1867–1868. It was carefully detached from two single-story wings on each side of the structure and moved to a location on South Main Street behind the Netherwood Block Building in 1895.

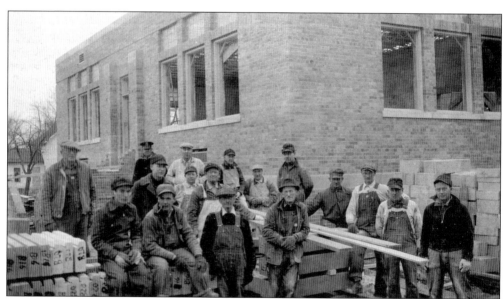

The Oregon Village Hall was constructed under the Works Progress Administration (WPA). Identified in the picture are Park Herrick (standing on the left) and policeman George Johnson. Over the years, the village hall has served as the site for many community services. In 1946, the two first-grade classes were taught by Mary Smith and Mabel Olson.

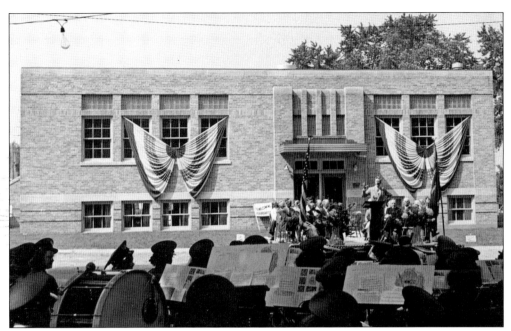

The village hall was dedicated on July 5, 1941. The main entrance was on the south side of the building, facing Waterman Park. Village administration offices and the public library were on the upper floor. The police department and a small jail occupied the rear of the building. A large meeting room with a kitchen was located on the lower level.

Forest E. "Steve" Madsen served as village president from 1937 until his death in 1973. During his tenure, he oversaw the building of the village hall in 1941 with no direct cost to the taxpayers. He was an active member of the Oregon Fire Department and a local businessman, operating a grocery store and meat market. He later built and ran the Waterfall Restaurant and Motel. Madsen also served on the Dane County Board as a supervisor for 33 years.

49

Oregon Engine Company No. 1 was organized on March 14, 1894. Harley Criddle was the first fire chief. In this photograph, Emmett "Shorty" Erfurth is shown in front of a water cannon, purchased in 1910, and a 12-man Niagara hand pumper, purchased in 1890. Cisterns located throughout the village supplied water to the pumper and cannon. The cisterns were refilled after each use.

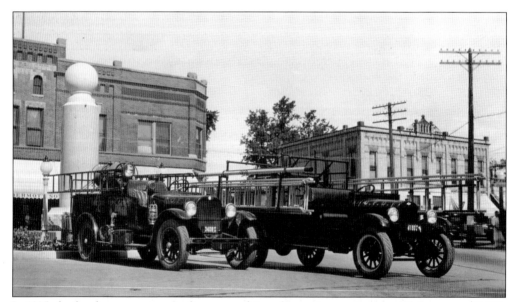

In 1925, the fire department put its first motor-driven fire equipment into use. The cost was $3,000. It had a 300-gallon tank and was capable of pumping 50 gallons per minute. A Chevrolet ladder truck was purchased in 1926. Gerald Booth Sr. was fire chief at this time.

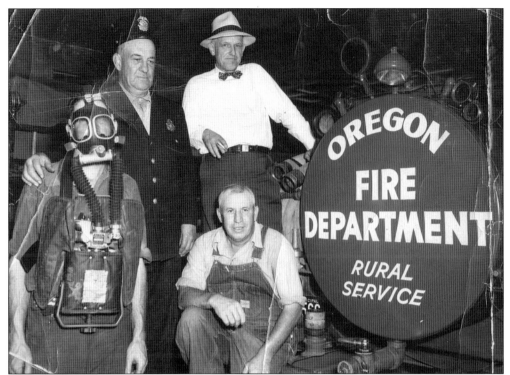

In 1940, a Ford tank truck with a capacity of 900 gallons was purchased by the towns of Dunn, Rutland, Fitchburg, and Oregon. This was the first tank truck for the fire department service in rural areas in Wisconsin and the first tank truck outside of Milwaukee County. In 1947, the Oregon Fire Department purchased its first oxygen mask. Shown in the above photograph are, from left to right, Capt. Raymond Noyce, wearing the oxygen mask; policeman George Johnson, a former fireman for 28 years; Norton Ames, chairman of the fire and police commission, and fire chief Ernest Culb. In the photograph below, volunteer firemen, many of whom were local businessmen, dropped what they were doing and raced to the station when the fire whistle signaled there was a blaze in the vicinity.

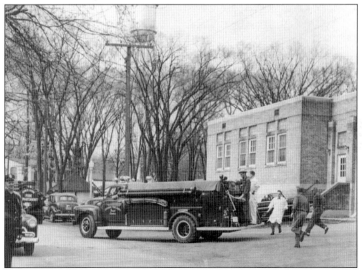

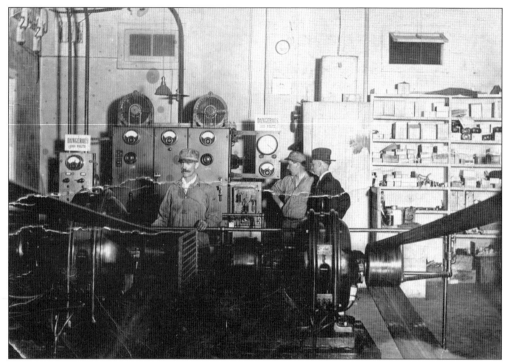

Identified in the photograph above are, from left to right, plant workers Clarke West, Wayne Thornton, and Walt Krumell. In 1906, a petition was received by the village board requesting the village be bonded for $8,000 to provide an electric power plant. It took 10 years for the Oregon Electric Company to become a reality. The first plant was located in back of the mill near the Cusick and Sweeney office on Market Street. The water supply was needed for the system's operation. Oil-burning engines were used to produce the "juice" necessary. The plant operated until 1920, when connection was made with power provided by the Wisconsin River Dam at Prairie du Sac, owned by Wisconsin Power and Light.

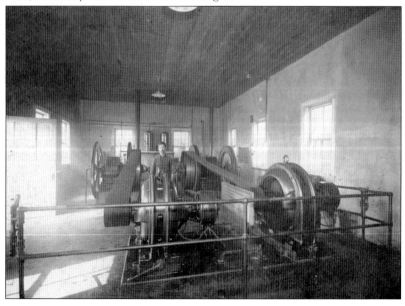

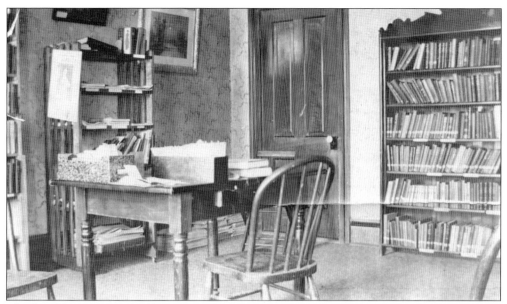

The first library was started by Jean Mennes Bennett in 1908. It was located in a room over the old Oregon Drug Company at 113 South Main Street. An official village public library began in 1910. Over the years, the library has occupied several locations and, in 1941, moved into the Oregon Village Hall. In 1920, all borrowers were told to burn all books in their homes due to the scarlet fever epidemic. In 1935, Hazel Russell was hired as a librarian.

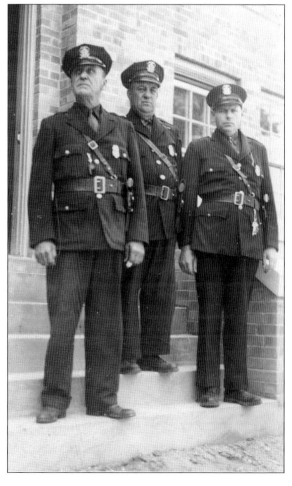

At the time of Oregon's incorporation, J.T. Hayes was elected the first constable and marshal, and Norris Getts was elected first justice of the peace. In 1922, a 24-hour service was established in the village with cooperation of the Business Men's Club. Before this, someone patrolled the village only during the nighttime hours. Police officers shown in this photograph are, from left to right, C.E. "Buck" Pledger Sr., George Johnson, and Maurice Phillips.

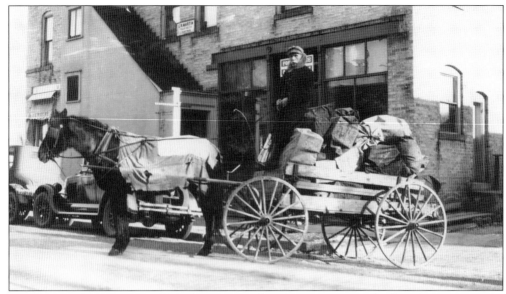

The first post office was established in 1848 with Egbert Bennett as the first postmaster. Peter Paulson is shown driving a cart with a load of Christmas mail. The post office building behind him was located on South Main Street in the rear of the Netherwood Block Building.

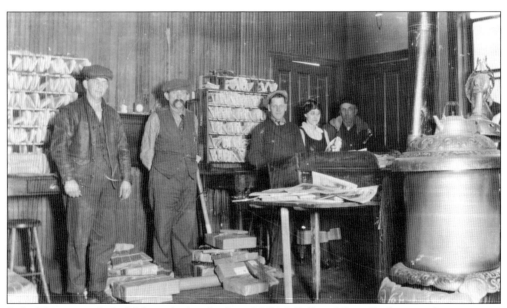

Sofus Thompson, Sofus Nelson, Arthur Paulson, Nell McGill, and Peter Paulson are shown sorting mail in 1923. Rural free delivery (RFD) was a great advantage to the farming community. Some rural carriers included Sofus Nelson, H.V. Chappel, John Gilbert, Peter Paulson, Soren Thomson, Will Minch, and Ted Elliot.

Five

EARLY CHURCHES

The part-log, part-frame house and tavern built by C.P. Mosely, near the site of the present-day water tower on Janesville Street, became a meeting place for business and religious meetings. The first services were held in the Mosely tavern in 1845. The First Congregational Church, which later became the First Presbyterian Church, was organized here.

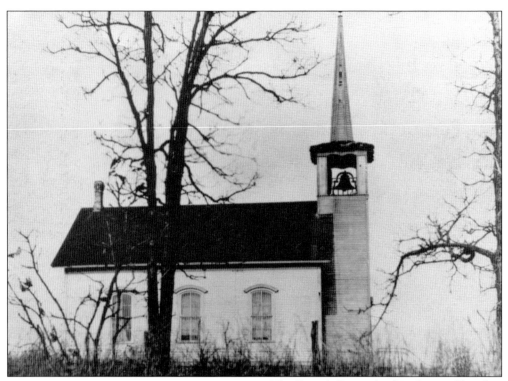

The Danish Evangelical Lutheran Church of Rutland was built in 1883. The church was quite distinctive with its tall spire and bell tower. For 46 years, the church stood on a hill in the town of Rutland, a mile south of the intersection of Center and Stone Roads. Rev. Falk Gjertson organized the first Danish congregation and became its preacher for many years.

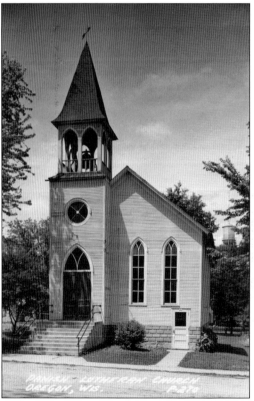

The village of Oregon was home to many Danish families. Their desire for a church in the village was realized when the Danish Lutheran Church was built on Washington Street in 1898. When the Rutland church was torn down, the bell was purchased for $25 and moved to the church in the village. The bell has hung in the Lutheran church in all of its four different locations over the years.

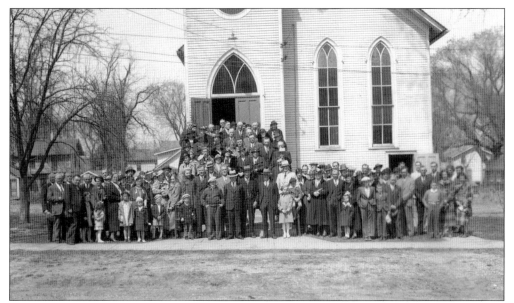

In 1936, the Danish Lutheran Church celebrated its 40th anniversary. Members of the congregation gathered in front of the church at 143 Washington Street. (Courtesy of St. John's Lutheran Church,.)

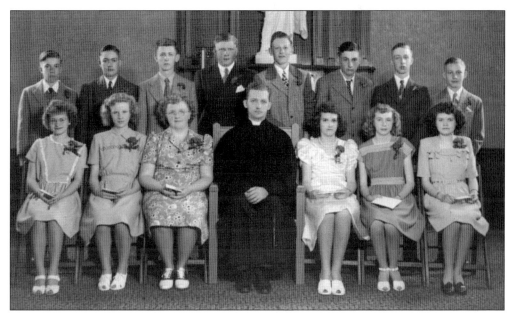

Identified in this photograph of the confirmation class of St. John's Lutheran Church on April 27, 1941, are, from left to right, (first row) Eunice Lawry, Joyce Swann, LaVonne Johnson, Rev. Ervin F. Bondo, Eunice Soderholm, Pearl Rasmussen, and Florice Nelson; (second row) Philip Ringhand, Harold Rasmussen, Donald Peterson, Ray Lawry, and Arnold Pollow. (Courtesy of St. John's Lutheran Church.)

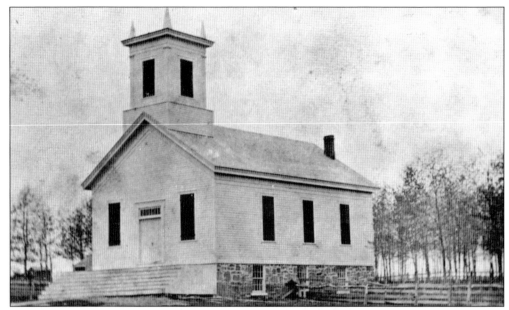

Prior to establishing the Methodist church, devotions were led by class leaders and later by a circuit preacher. Meetings took place in barns, homes, taverns, schools, and even outdoors. Services were held in the Presbyterian church until the Methodist church was completed in 1862. Stoddard Johnson donated the land on which the church was built. (Courtesy of People's United Methodist Church.)

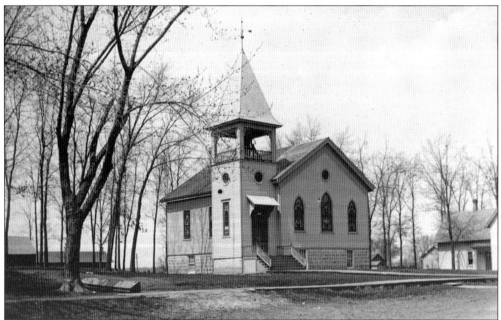

In 1895, the original Methodist church building was remodeled. Social rooms downstairs were improved and a kitchen added. New hardwood floors were laid in the auditorium, new pews and a pulpit were installed, and the belfry was added. Peter Taylor, a faithful member, loaned the money for the project. In 1899, when the debt had been reduced to a small sum, Taylor cancelled the balance of the note. He died the following day.

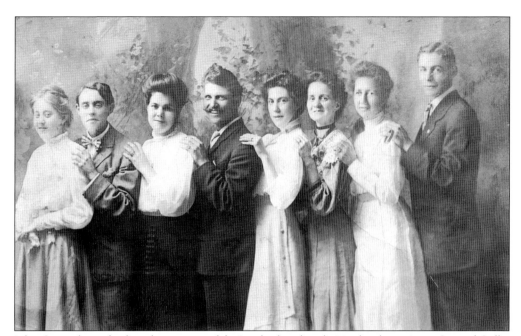

John Coward was the first choirmaster of the Methodist church. His daughter Hattie Coward Colby sang all of her young life with the adult members of the choir. She held a record of furnishing the music of the church for over 60 years. She retired in 1935 from active music work in the church. The choir members are, from left to right, Nellie McGill, Don McGill, Retta Murphy, Ross Martin, Mabel Litch, Belle Worden, Hattie Colby, and Charles Colby. (Courtesy of People's United Methodist Church.)

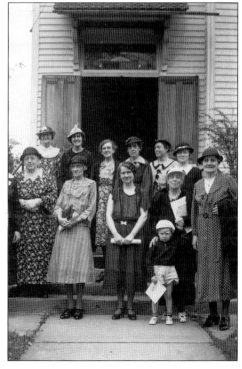

The Mother's Club was organized to assist the faculty of the church school in its work. Katie Kelley was the first president of the club. Each child graduating from the lower grades received a Bible as a gift from the Mother's Club. From left to right are (first row) a Mary Williamson, Velma Horton, Elsie Clark, a Edith Culp, Dale Culp (little boy), and a Sofee Linn; (second row) a Mrs. Snooks, Ettie Cook, Etta Cook, Mabel Litch, Mattie Mahaffey, and Irma Sholts. (Courtesy of People's United Methodist Church.)

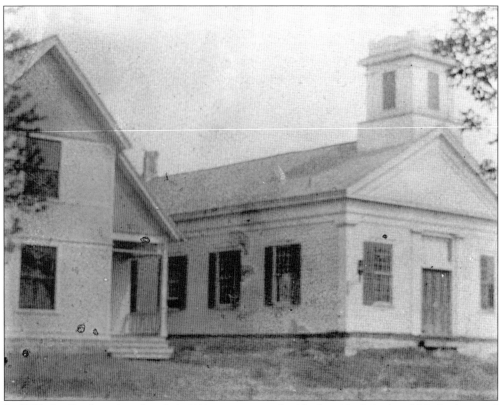

In 1855, the Presbyterian church building was erected with the aid of the local Methodists and was occupied by both congregations until the Methodist church was completed in 1862. Charles Waterman donated the land. In the fall of 1892, the women of the Ladies' Aid Society initiated a church-wide campaign to build a manse upon the church lot. It was built by Elias Jacobus and completed in 1893.

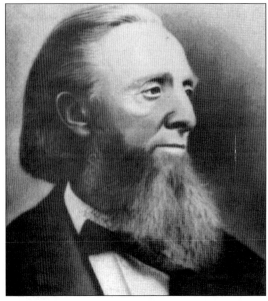

Rev. Matthew A. Fox was born in 1813 and began a pastorate in 1845 with the Presbyterian church, which endured for nearly 40 years. He was educated, talented, and very interested in the welfare of all of his parishioners. Rev. Enias McLean took over after the passing of Revered Fox in 1883.

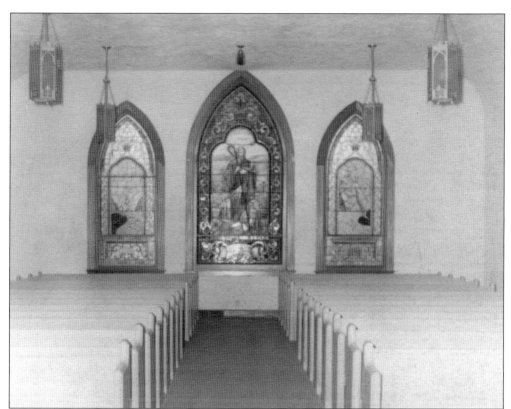

Almost anyone entering the First Presbyterian Church first notices the stained-glass windows. All of the windows were installed at the time of the 1895 renovation. The center stained glass was a gift to Rev. Matthew A. Fox from his son James M. Fox.

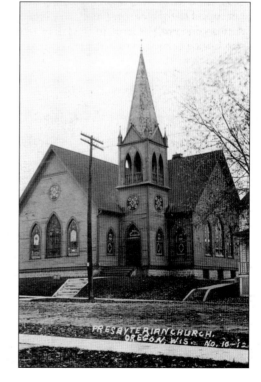

At the 50th anniversary on April 25, 1895, plans were adopted to remodel and enlarge the church. Work was completed, and the church was dedicated on December 21, 1895. The remodeling included the addition of a steeple, a side room, and enlargement of the sanctuary.

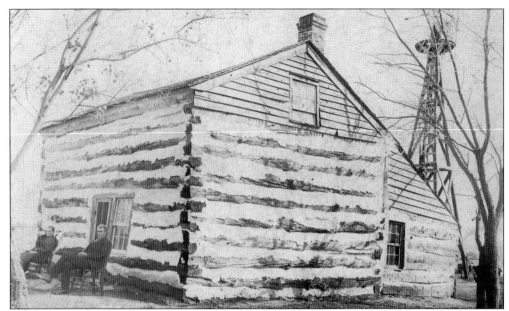

The Kinney log cabin, located on Irish Lane, was the site of the earliest Catholic masses in the St. Mary's/ Holy Mother of Consolation parish area. The George Fox cabin also served as a meeting place for Catholic services. The Kinneys arrived in Fitchburg in 1844. Priests came from Madison to say Mass. Michael and Alice Kinney are shown sitting in front of the Kinney cabin in 1880. (Courtesy of the Kinney family and Fitchburg Historical Society.)

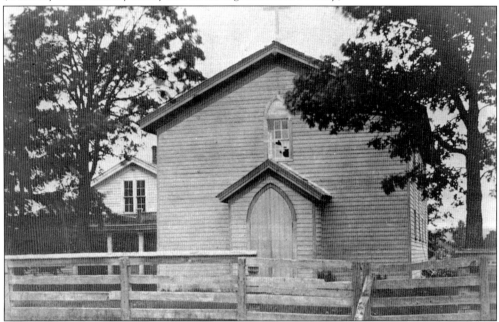

The Catholic parish was organized in 1856 and comprised the townships of Dunn, Fitchburg, Oregon, and Rutland. The land for the first church and cemetery was at Oak Hall in the town of Fitchburg. The land was deeded to the parish by Barney McGlynn and his wife, Ann, for $1. It was completed and blessed by Bishop John M. Henni on August 8, 1857. On the same day, 40 members were confirmed.

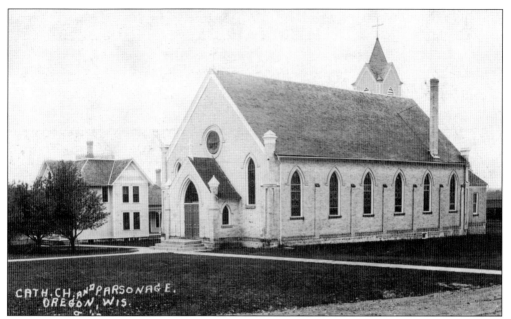

CATH. CH. AND PARSONAGE.
OREGON, WIS.

In 1885, Fr. Joseph Knox purchased a very desirable five acres of land on the west side of North Main Street for the Catholic church. The church was dedicated on September 26, 1886. A long, wooden shed was built west of and across the road from the church. It was divided into stalls where horses and buggies of the churchgoers could be protected from the weather. The parsonage was built south of the church in 1889.

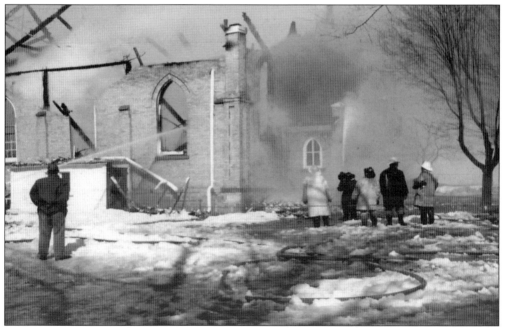

On March 16, 1961, the Holy Mother of Consolation Church in Oregon was destroyed by fire, despite the desperate efforts of five fire departments. The parsonage was saved, as was the parochial school. The firemen were able to save most of the furniture and fixtures in the basement. The fire left only the brick walls and part of the bell tower standing.

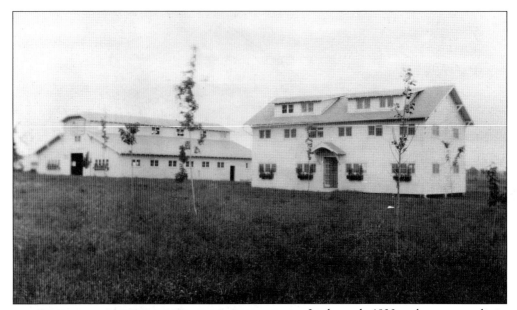

In the early 1920s, a large evangelistic complex known as the Hallelujah Camp Grounds was founded and built by a former Congregational minister, Rev. C.H. "Jack" Linn. The campgrounds were located on Janesville Street and what is now South Perry Parkway. The site grew to include the tabernacle, dormitory, a print shop, and several identical white cottages. Interdenominational religious services in the summer were attended by hundreds of individuals from throughout the United States.

Clement Linn, also known as Jack Linn, was born in Nelsonville, Ohio, on April 1, 1886. He married Sofee Nelson on December 7, 1915, in Iowa. Prior to becoming an ordained minister in the Congregational Church, he was a newspaper editor in Arkansas and had appeared onstage on Broadway. Together, the Linns traveled the world preaching. Rev. Clement died on December 13, 1940, at the age of 54.

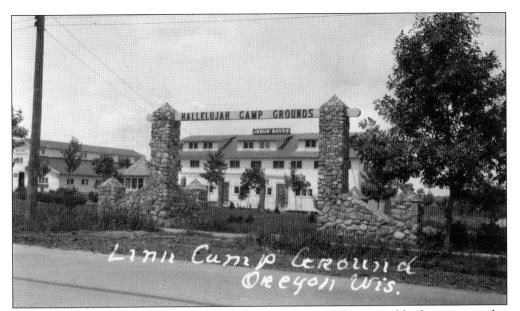

Reverend Linn landscaped the grounds using many beautiful flowers and bushes grown in his greenhouse located on the property. He took great pride in the sunken gardens, fountains, pergolas, and long, winding sidewalks that adorned the campgrounds. His parents lived in the small house on Janesville Street. Clement's father, Sherman Linn, built all of the stonework on the property, some of which remain today in front of the Linn house.

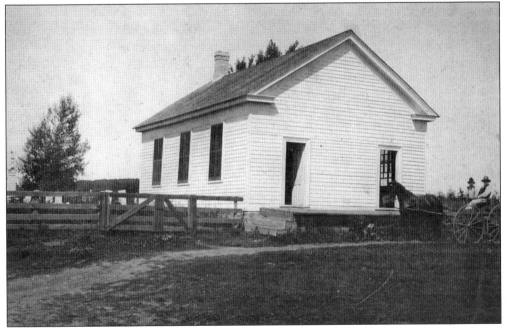

Many Rutland settlers were members of a Protestant sect called the United Brethren in Christ. Prior to being designated a congregation in 1851, families met in homes, selecting "class leaders" to conduct devotions. In 1852, the congregation acquired an acre and half of land for $10 from David and Jane Anthony. The church building was completed and dedicated in 1853. This photograph shows the church as it appeared in 1885. (Courtesy of Mark Hanson.)

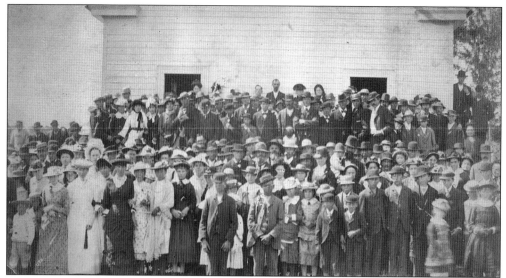

A meeting held in the Rutland church in September 1858 established the First United Brethren State Conference of Wisconsin. The date and the identities of the people in this photograph are unknown, but it is likely they are members of the church. (Courtesy of Mark Hanson and Nancy Hook.)

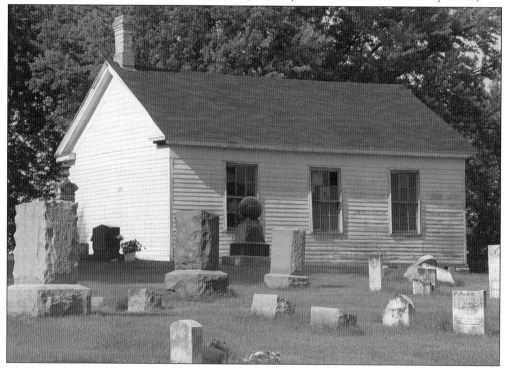

The United Brethren Church of Rutland is located three miles south of the village of Oregon on Highway 14. The church and congregation were very active until services were discontinued in 1912 due to a dwindling membership. This photograph is a view of the church and cemetery in the 1930s. In 2004, a group organized as the Friends of the Rutland Center Church began a nearly decadelong effort to restore the church building. It stands today as a landmark of the Rutland area. (Courtesy of Mark Hanson.)

Six

SCHOOLS

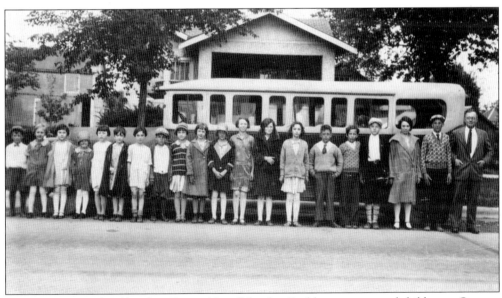

In 1926, the first school bus from Prairie View School in Fitchburg transported children to Oregon. These students marked the occasion, lining up for a photograph. Pictured, from left to right, are Robert Keenan, Betty Johnson, Anna Kivlin, Virginia Johnson, Blanche Merrick, Eleanor Stone, Edna Merrick, David Schuster, Dorothy Keenan, Margaret Stone, unidentified, Dorothy Merrick, Alice Merrick, Mary Stone, Dick Schuster, Ray Rice, unidentified, Gladys Merrick, Wayne Rice, and Peter H. Dvergedal (driver).

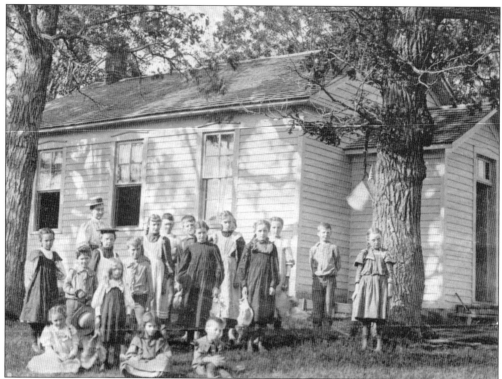

In 1846–1847, a 12-by-16-foot log school was built on the David Tipple land. The first teacher was Mary Graves. In 1850, when the school district was formed, this school was designated as District No. 1, or the Tipple District. The 1853 frame building shown here was a bit bigger, 20 by 26 feet, and located on the corner of Oakhill Road and present US Highway 14.

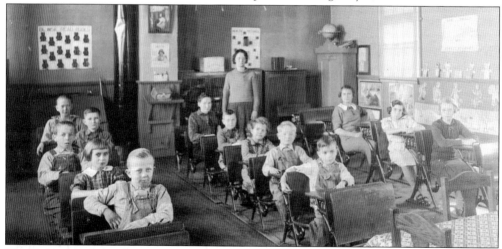

The Storytown School was located southwest of Oregon and named for three families by the name of Storey. The 1840s schoolhouse was replaced by a larger, brick building in 1882. Pictured are, from front to back, (left row) Sammy Ace, Marie Pernot, Raymond Lawry, Bernard Murphy, and Melvin Ace; (middle row) Russell Pernot, Roger Lawry, Helen Lamboley, Forrest Faulks, and Gladys Murphy; (right row) Eunice Lawry, Rose Pernot, and Mary Lamboley. The teacher is Katherine Sullivan. (Courtesy of the Sam Ace family.)

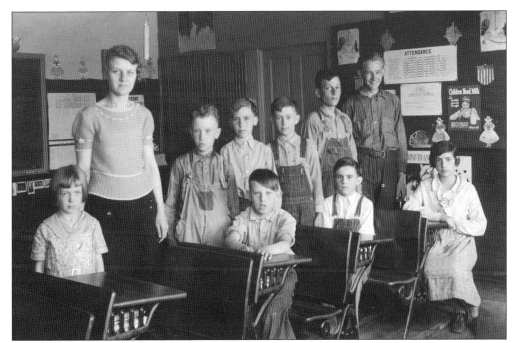

Locust Grove School was located near the intersection of Glenway and Locust Grove Roads, by an area called Dane Corners. The school was built in the 1880s and closed in 1935. The building was moved to Brooklyn, where it became a home. Pictured are, from left to right, (first row) Arlo Frederickson, Ralph O'Brien, and Regina Eagon; (second row) Lorraine Lewis, Thelma Nelson Gefke (teacher), Paul Damson, Robert O'Brien, Herbert Lewis, Keith Thornton, and Harvey Frederickson.

In 1861, a one-room frame school was erected in the village, and in 1867, wings were added to the structure. When another school was built in 1895, this building was divided into three sections. The center section was moved to South Main Street, behind the Netherwood block, and served as the village hall. The two side-wing sections were moved to North Main Street and became homes at 414 and 418 North Main Street.

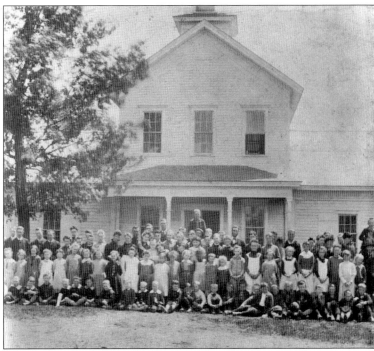

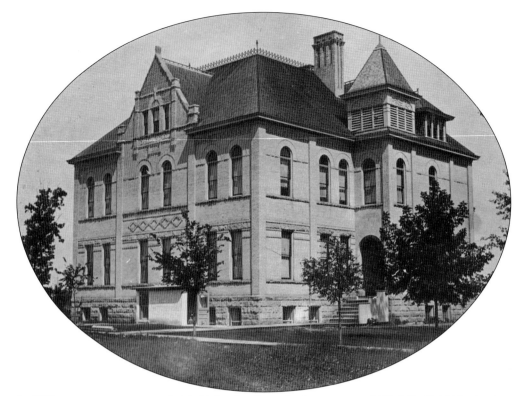

In 1895 a new two-story, tan-brick high school was built at a cost of $12,000–$14,000. At that time, the principal's salary was $100 a month; the teachers made between $25 and $88 a month. This building was torn down in 1966.

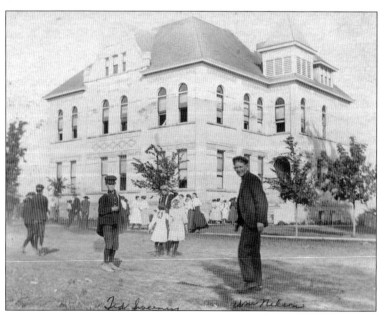

The 1895 school was built for first-grade through high school students. The first occupants included 224 pupils and 6 teachers. It had a huge attic, which was later used for classes. There was no kindergarten in those early years. This photograph from 1905 depicts Ted Sweeney (left) and Uni Nelson (right) in the foreground.

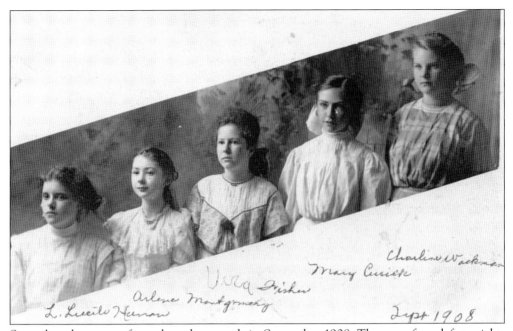

Several students pose for a class photograph in September 1908. They are, from left to right, Lucille Hanan, Arlene Montgomery, Vera Fisher, Mary Cusick, and Charline Wackman.

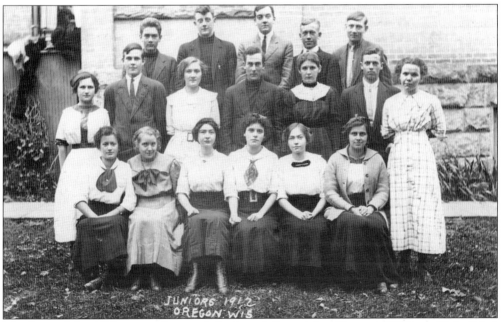

Members of the 1912 junior class include, from left to right, (first row) Wilmay Zink, Ethel Williamson, Arlene Montgomery, Lucille Hanan, Mary Cusick, Eva Theabold, and Esther Whalen (standing); (second row) Rachael Garvoille, Homer Madsen, Ada Johnson, Ora Green, Catherine Melville, and Adelbert Peterson; (third row) Lawrence Egan, William Elliott, Vincent Kivlin, Howard Zink, and Roy Egan.

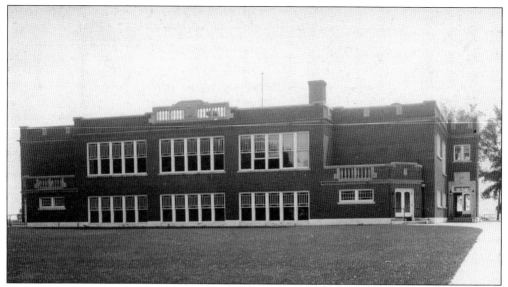

The Red Brick School building was constructed in 1922 at a cost of $74,777, plus $6,000 for equipment. This structure was to house the high school, but in just a few years, seventh grade, eighth grade, and the kindergarten were moved to the Red Brick.

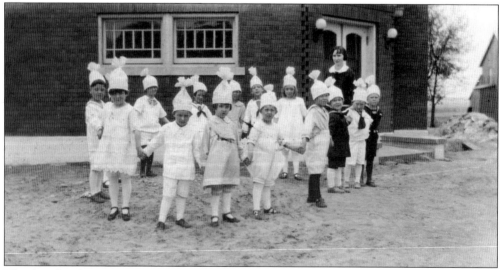

The first kindergarten in the United States was started in Watertown, Wisconsin. This photograph shows one of Oregon's first kindergarten classes outside the Red Brick School for a group activity.

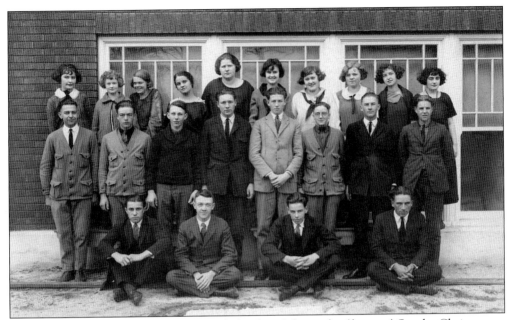

The Oregon High School class of 1924 includes, from left to right, (first row) Stanley Christenson, Charles Orvold, Stanley Barr, and Howard O'Niel; (second row) Kenneth Gillette, George Larson, Max Gefke, Sheldon Tusler, Evan Ace, Harold Benson, Harold Dunn, and Farnum Flint; (third row) Ann Cusick, Helen Crotty, Mildred Patterson, Edna Coggins, Bernice Matsen, Florice Peterson, Delett Sholts, Sylvia Johnson, Bernice Barry, and Mary Scanlan.

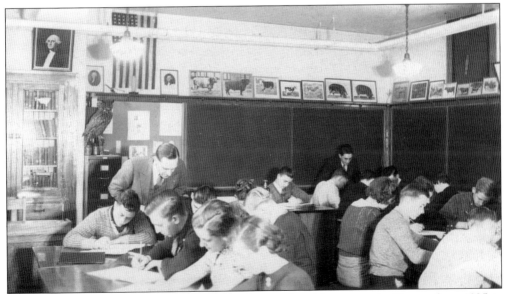

Clarence H. Bonsack served as the vocational agricultural instructor in Oregon from 1925 to 1938. He went on to work for the State Board of Vocational Agriculture. Bonsack became known at "Mr. FFA" in Wisconsin for his years of service to the Future Farmers of America.

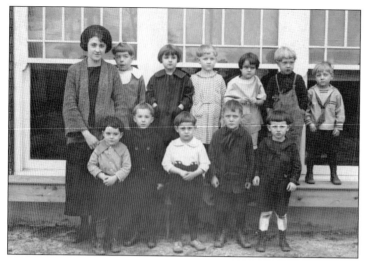

In 1923, a Miss Honeycomb was the teacher of the kindergarten class at the Red Brick School. Pictured are, from left to right, (first row) Samuel Scanlan, Norman Champion, Lyle Peterson, unidentified, and Dean Pease; (second row) Miss Honeycomb, Ralph Conklin, Betty Booth, Dorothy Mahaffey, Maxine Curless, unidentified, and Donald Bethel.

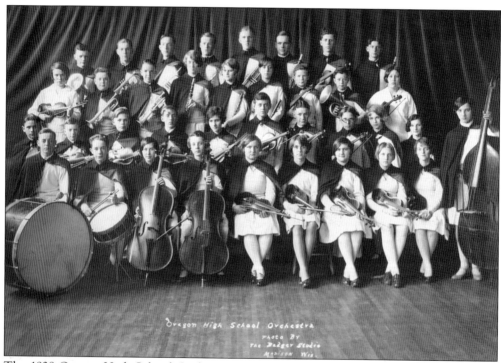

The 1928 Oregon High School Orchestra members are, from left to right, (first row) John McDermott, Charles Sweeney, Mildred Litch, Elizabeth Kern, Letha Williamson, June Ames, Dorothy Sholts, Bernice Knudson, Ione McDermott, and Violet Ringhand; (second row) Reginald Terwilliger, Ronald Hobbs, Olaf Johnson, Robert Curless, Luella Litch, Leo White, Edward Showers, Clinton Lalor, Clarice Sweeney, and Alta Dreher; (third row) Gladys Merrick, Art Sweeney, Claire Flint, Mary Devine, Helen Reindahl, Elaine Thornton, Frederick Culp, Lester Crotty, and Mava Jensen; (fourth row) Lester McDermott, Stanley Tusler, Paul Hobbs, Carrol Kellor, Leslie Knudson, Phillip Barry, Ansel Christensen, and Kermit Haynes.

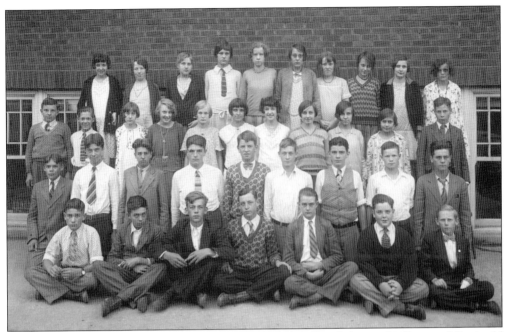

The 1931 Oregon High School sophomore class includes, from left to right (first row) Reginald Terwilliger, Clarence Friday, Charles Lundey, Emmet Manion, Roy Christensen, Art Sweeney, and Harold Nygaard; (second row) Stanley Johnson, Collins Richardson, John Ace, Edward Pernot, Leonard Sather, Keith Beechel, Leo Purcell, Frederick Culp, and Maurice Joppa; (third row) Lyle Nelson, Gordon Vroman, Ruth Morehouse, Clarice Quale, Inez Jones, June Ames, Doris Litch, Lucille Hammersley, Dorothy Rowlands, Lillian Wiese, and John Manion; (fourth row) Dorothy Litch, Mary Manion, Bernice Knudson, Dorothy Larsen, Cecelia O'Neill, Nora Thornton, Margaret Olsen, Florence Herring, Merle Dale, and Catherine Clark.

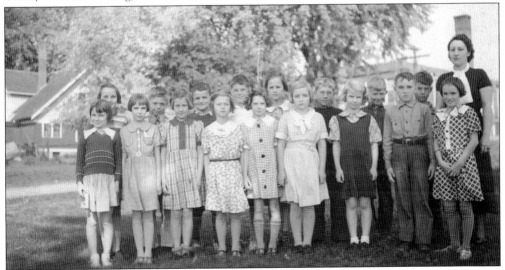

This 1936–1937 class photograph includes, from left to right, (first row) Geraldine "Sue" Newton, Arlene Huset, Viola Pasley, Jan McMicken, Cleo Neath, Nelladele Weaver, Mary Jane Larson, Francis West, and Betty West; (second row) Lois Pease, David Mandt, Gordon Owen, Robert Aldrich, Betty Nesbit, Raymond Olson, Willis Reindahl, Billy Lyons, and Mava (Jensen) Berger (teacher).

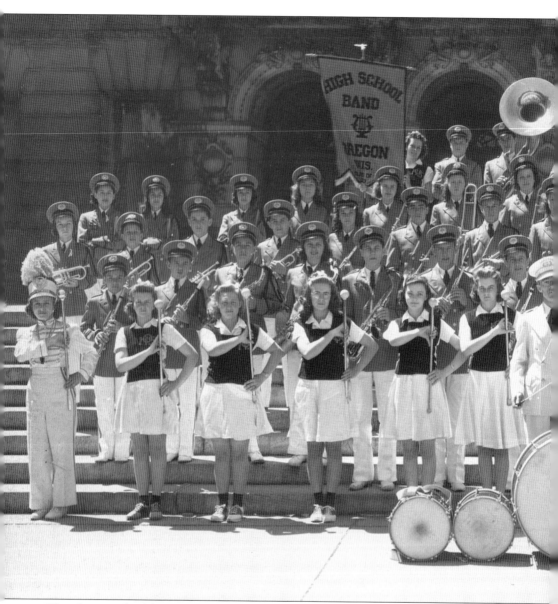

This photograph of the Oregon High School Band of 1941 includes, from left to right, (first row) Helen Kelbel, Florence Barry, Virginia Olson, Janice Dalsoren, Audrey Pledger, Grace Barry, Theodore Kexel (director), Delores Newton, Jean Gorman, Gladys Murphy, Mary Lundey, Patricia Killerlain, Lorraine Lewis, and Vera Pledger; (second row) William Scott, Donald Denson, Edmond Larson, Muriel Onsrud, Clifford Conahan, Arlo Frederickson, Dick Inman, Sue Griffith, Ruth Schuster, Lois Ann Ogilvie, Elaine Grinnell, Mae McMicken, and Eunice Lawry; (third row) Sue

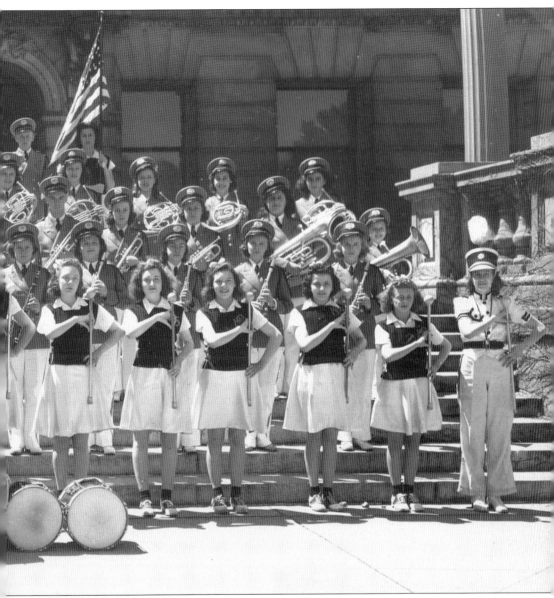

Newton, Robert Lalor, William Sweeney, Robert Dreher, Lois Ann Pease, Lyman Anderson, Robert
Lythjohan, Virginia Johnson, Curtis Starry, Robert Newton, Eileen McCann, Jane Schuster, Ardis
Sarbacker, and Lenore Judd; (fourth row) Mary Bryne, Betty Herfel, Rita Dreger, Joyce Swann,
Lucille Westby, Lois Griffin, Patricia Martin, Mary White, Betty Sweeney, Phyllis Rasmussen,
and Virginia McCann; (fifth row) Irene Lyons, Philip Booth, Robert White, Lawrence Mandt,
Cletus Henriksen, and Helen Keenan.

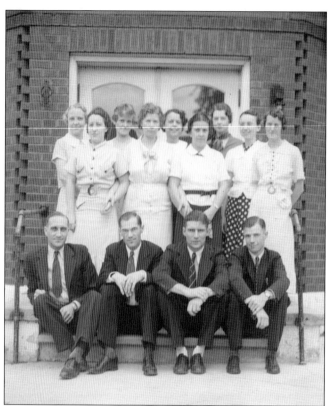

The teaching staff in 1936 includes, from left to right, (first row) C.H. Bonsack, E.A. Kozlovsky, Charles Parr, and Theodore Kexel; (second row) Hazel Stevenson, Mava Jensen, Huldah Swedburg, Connie Grinsrude, Helen Thorson, Marie Paulsen, Bernadine Myers, Nellie Smith, and Mary Baxter.

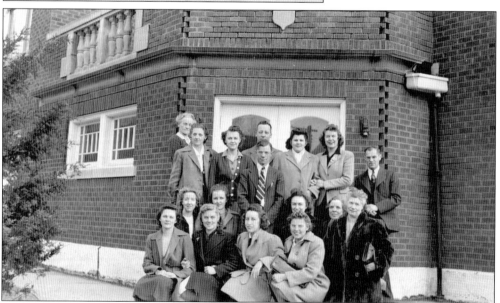

The teaching staff in 1944 includes, from left to right, (first row) Miss Taylor, Mrs. Fortney-Peterson, Mava Jensen, Ruth Burrill-Thornton, and Marie Paulson-Nelson; (second row) Bertha Gotfried, Mrs. Doyle, Mrs. Burnie, and Mary Anderson; (third row) Hulda Swedburg, Alice Christensen, Miss Vodak, H.J. "Pat" Morrissey, Theodore Kexel, Miss Boos, Miss Chandler, and Edwin A. Kozlovsky.

Students attending the 1942 junior class prom are, from left to right, Patricia Todd, Lyman Anderson, Sue Ames, Norwin Sarbacker, Lucille Westbye (queen), Gunder Lundey (king), Robert Lythjohan, Ruth Schuster, William Booth, Eileen McCann, Phillip Sheil, and Evelyn McCann. Children Michael Hayes and Jeanne Martin were the junior king and queen.

Several members of the Oregon class of 1942 became entertainers. Shown from left to right are (first row) Virginia Johnson, Cletus Henriksen, Clifford Conohan, Philllip Booth, and Lyman Anderson; (second row) Art Rowe, Irene Lyons, Vera Pledger, Audrey Pledger, Grace Barry, Walter Hoffman, and class advisor Mary Anderson.

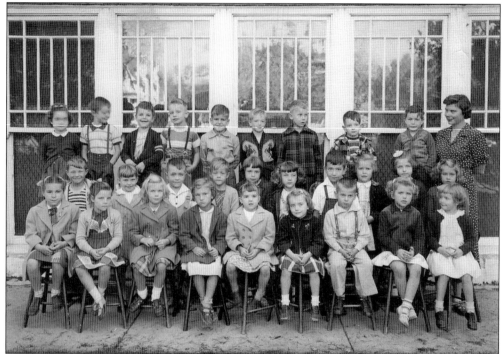

The 1950s had many baby boomers. The 1950 kindergarten classes were full. The morning kindergarten class photograph includes, from left to right, (first row) Ann Champion, Susan Madsen, Elaine Pierce, Charlene Haas, Sally Booth, Marlys Christensen, John Churchill, Sharon Lemke, and Susan Smith; (second row) James Schenk, Kathleen Raasch, Arthur Richardson, Gary Scoville, Zulla Meyer, Virginia Bryant, Robert Luchsinger, Martha Abrams, Sharon Kivlin, and Sharon Jabs; (third row) Susan Scanga, Danny Butts, Calvin Frederickson, William Heiking, Ronald Faust, Alan Noyce, Arthur Thornton, Robert Gallagher, William Newton, and Priscilla Optiz.

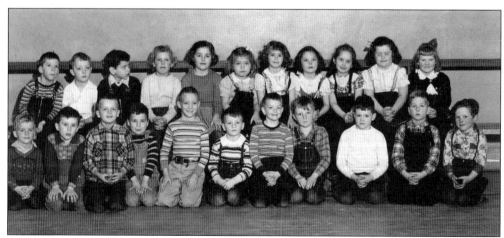

The afternoon 1950 kindergarten class includes, from left to right, (first row) Robert Fishrup, William Custer, William Weisenberg, Edward Steiner, David Kurth, Gerald Schneider, Alan Noyce, James Byrne, Kenny Searl, Robert Ace, and Robert Adams: (second row) James O'Neal, Gary Storzbach, John Peters, Marjorie Gohre, Terry Kivlin, Linda Berkan, Verelene Haukereid, Judy McGowan, Ann Richardson, Betty Wick, and Trudy Graves.

Seven

Sports and Recreation

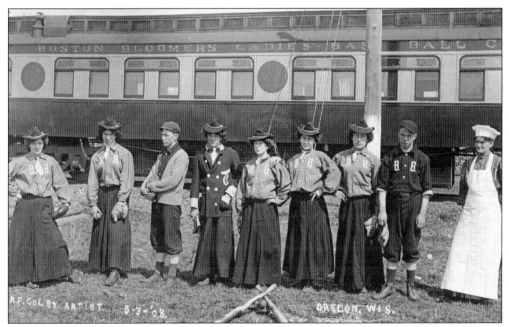

In the 1890s, some all-female baseball teams were organized. One of the most well-known teams was the Boston Bloomers Ladies' Baseball Club. They played ball in Oregon on May 3, 1908, and arrived in their private railroad car. The games were played in a field across the creek from the Andrew Christensen farm off Jefferson Street. The team name came from the pants that some women started wearing instead of skirts.

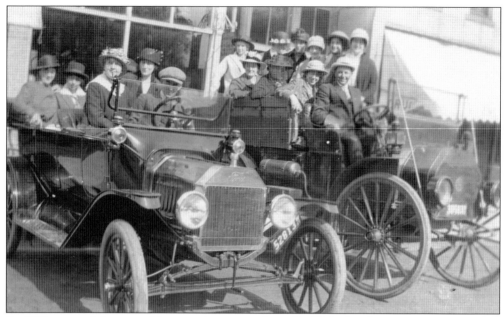

By 1910, automobile ownership came into general use. In 1915, this Oregon group motored to Lake Kegonsa to enjoy a summer day. Howard Kivlin (left) and Erwin Jeffrey drove the group of young women; all are wearing fashionable hats.

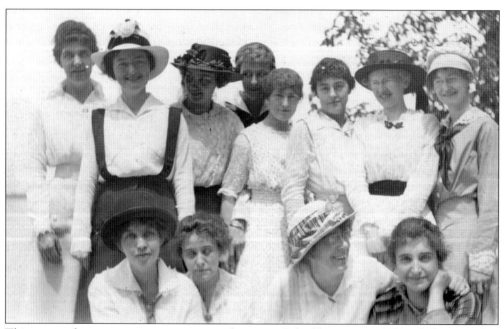

This group of young women at a picnic gathering at Lake Kegonsa in 1915 includes, from left to right, (first row) Margaret Kivlin, Sofee Nelson, Cornelia DeJean, and Blanche Anderson; (second row) Nell Kivlin, Mona Paulson, Ruby Pease, Genevieva "Veve" Dunn, Bessie McAvoy, Jesse White, Alice Booth, and Elsie Pease.

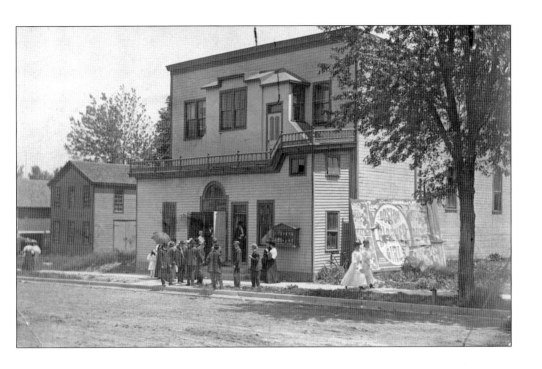

Cronk's Opera House was the center of social activities for many years in the early 1900s. This two-story building had a roller-skating rink and was the location for high school graduations, plays, and other entertainment. Several young people shown in the photograph below are standing in front of the opera house. From left to right are (first row) Blanche Shampnor, Dallas Lamont, Perry Gould, and John Keenan; (second row) unidentified, Norton Ames, Walter Peterson, and Burr McWilliams.

Playing horseshoes was a popular game in the early days. These men are tossing horseshoes on the grounds adjacent to the Badger Bicycle Factory.

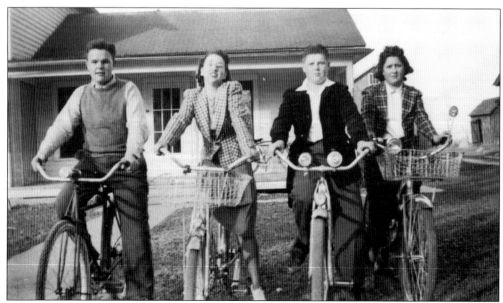

This 1939 bicycle group includes several Oregon High School students. The four are, from left to right, Norwin Sarbacker, Mary Jean Pease, Phillip Booth, and Ardis Sarbacker.

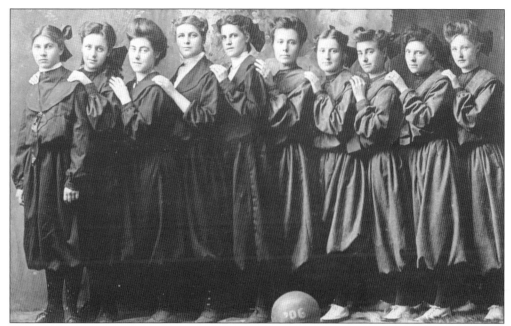

The 1906 girls' basketball team is dressed in full attire. Players are, from left to right, Hazel Criddle, Ione Tussler, Lou Dreher, Florence Hanen, Elsie Short, Carrie Fox, Louva Chappel, Florence Feeney, Lila Theobold, and Mabel Fisher.

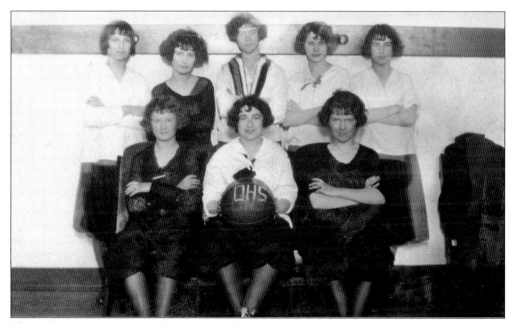

The 1924 Oregon High School girls' basketball team includes, from left to right, (first row) Helen Crotty, Ann Cusick, and Regina McDermott; (second row) Eva Bethel, Ann Cusick, Mildred Goslyn (coach), Elizabeth Diedrich, and Ellen Cusick.

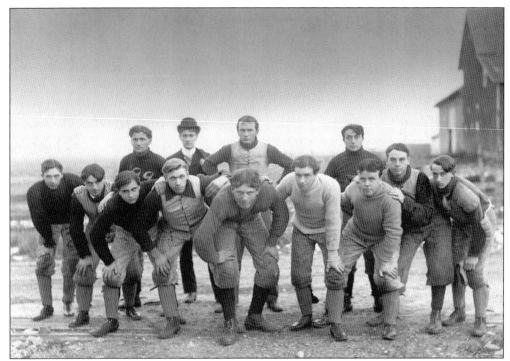

Oregon High School did not have a football team until 1914. In earlier years, young men from the village and surrounding areas formed their own teams. They competed against similar teams in the area.

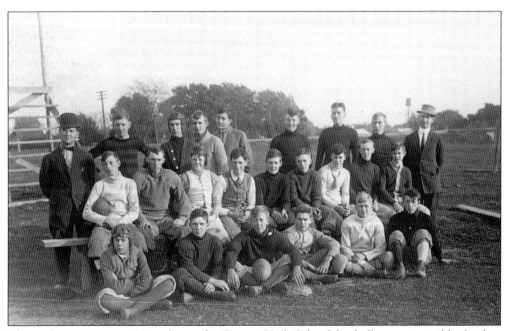

The students are competing to be on the Oregon High School football team—possibly the first official high school team. The practice fields were located on Jefferson Street. The water tower can be seen in the background.

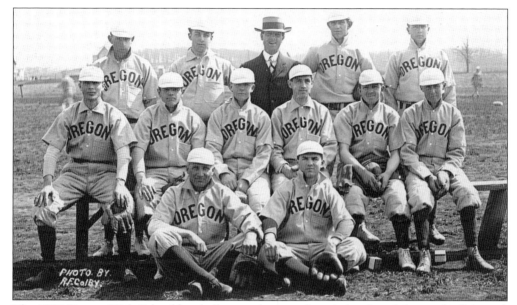

The 1906 Oregon High School baseball team photograph includes, from left to right (first row) Bert Hansen and Gerald Booth; (second row) Edward Buche, Roy Richards, Sam Wolfe, William Dunn, Bob Pratt, and Tom Fahey; (third row) Roy Pease, Art Chappel, A.R. Jones, "Squirt" Rice, and William Minch.

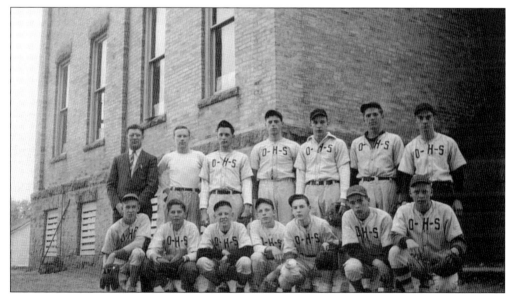

The 1940 Oregon High School baseball team photograph includes, from left to right (first row) Robert Lythjohan, Edward Lawson, Howard Zink, Stanley Gefke, William Booth, Lyman Anderson, and Cletus Henriksen; (second row) Charles Paar, Dale Smith, Robert Keenan, Jack Sheil, Robert Gefke, Lester Dalsoren, and Robert Newton.

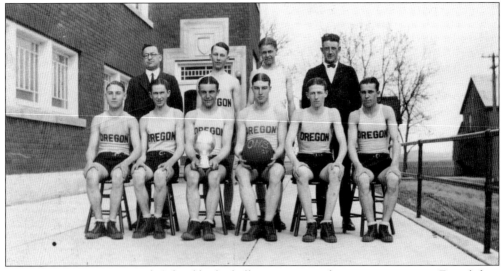

This 1923–1924 Oregon High School basketball team went to the state tournament. From left to right are (first row) Roy Butler, Stanley Montgomery, Elmer Nelson, Forest Madsen, Evan Ace, and Stanley Christenson; (second row) Prof. Ernest Ceisel, Max Gefke, Clarence Nielson, and Will Elliot (coach).

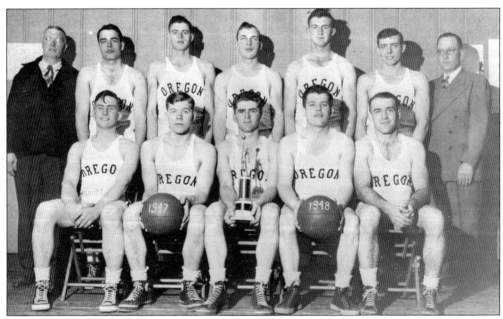

This Oregon town basketball team photograph from 1947–1948 includes, from left to right, (first row) William Lyons, David Mandt, Lester Dalsoren, Bernard Martin, and Robert Dreher; (second row) Forest "Steve" Madsen, Lyman Anderson, Jack Sheil, Robert Gefke, Robert Devine, Lawrence Mandt, and Gilmore Olsen.

Boxing was part of the Oregon High School athletic program between 1938 and the late 1940s. Charles Paar, shown in the photograph, was a former Golden Gloves fighter and the team's first coach. The boxing team began competing in 1941 with area schools and won the Madison urban championship in 1941 and 1944.

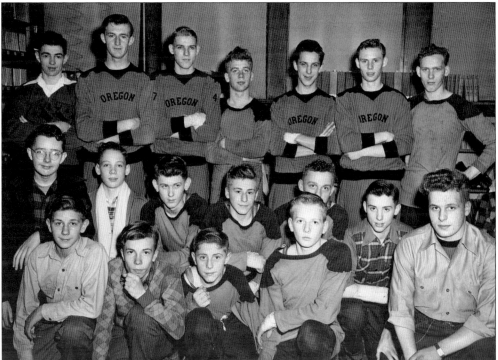

The 1947 Oregon High School boxing team includes, from left to right, (first row) William Elliot, George Johnson, Wallace Hegge, Lee Henriksen, and Ron Erfurth; (second row) David Ramey, Ralph Sholts, Duane Miller, John Eith, Francis McCann, and John Barger; (third row) Don Volk, Robert Devine, Robert Mandt, Jerry Schwenn, Rollins Hubbard, Christopher Schneider, and Wilton Richardson.

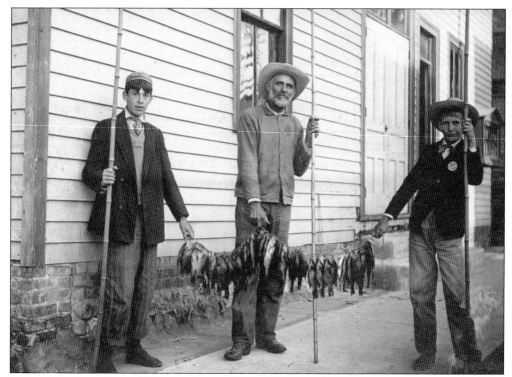

William L. Ames (center), his son Norton Travis Ames, and an unidentified friend (left) stand in front of Cronk's Opera House to show their results after a day of fishing. This photograph was taken about 1907.

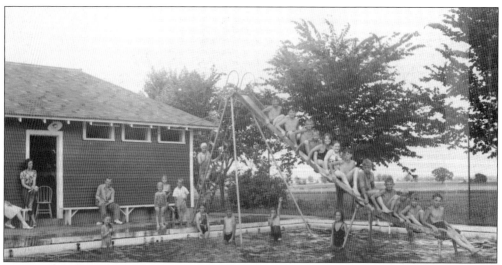

In 1933, the Kiser family donated land to the Oregon firemen to be used as a park. The firemen began plans for a swimming pool and had the old creamery torn down. The pool was completed mostly with volunteer labor. Dedication took place on August 18, 1934, at the time of the Oregon Festival. The firemen operated the pool for 27 years.

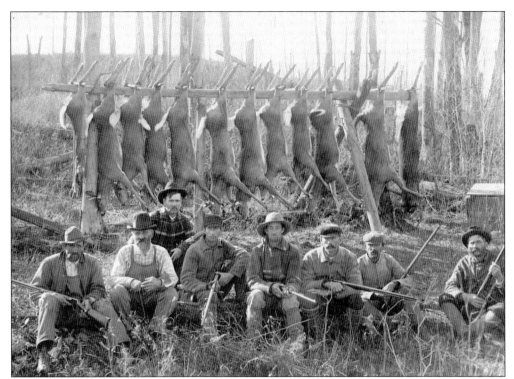

This group of Oregon men gathered after a successful deer hunt in 1905. From left to right are Comer Shampnor, Leisch Frary, William Pritchard, Earl Pritchard, James Stone, Samuel Barry, Clarence Page, and Carl Pease.

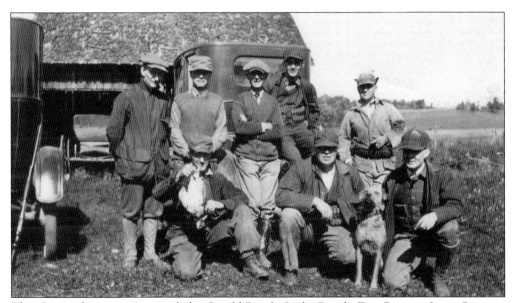

This Oregon hunting group includes Gerald Booth, Leslie Booth, Dan Benson, Louis Sprague, Howard Kivlin, Dr. William Ogilvie, Herbert Golden, and Orwin Kruse from Midddleton. They motored to Leland, Wisconsin, where they enjoyed a Sunday of hunting.

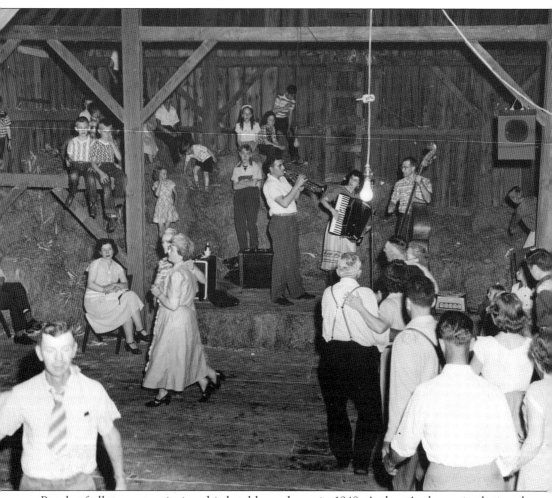

People of all ages are enjoying this local barn dance in 1948. Arthur Anderson is playing the trumpet. At one time, he was director of the Hal Mack Band. His wife, Marian, is sitting in the chair. Arthur was a 1937 graduate of Oregon High School and salutatorian of his class. In addition to being a musician, he worked at Rayovac for 32 years and was active in many organizations. (Courtesy of Patricia Anderson Wilkening.)

Eight

Clubs and Organizations

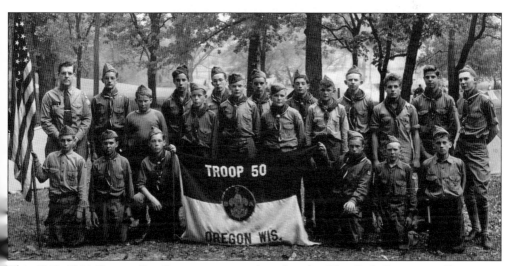

This 1943–1944 Oregon Boy Scout troop is gathered at the Olin Park Camporee. Shown are, from left to right, (first row) Louis Spink, Jay Flint, Ralph Sholts, George Johnson, Dale Culp, and David Peterson; (second row) Stanley Larson, Harlow Roby, Halvor Bjornson, Donn Wheeler, Rodney Nedlose, and Ron Erfurth; (third row) Earl M. Wheeler (Scoutmaster), Douglas Peterson, Rollie Hubbard, Gerald Johnson, Earl "Bill" Newton, Robert Spink, Dale Alme, Neil Rasmussen, and Thomas Schneider.

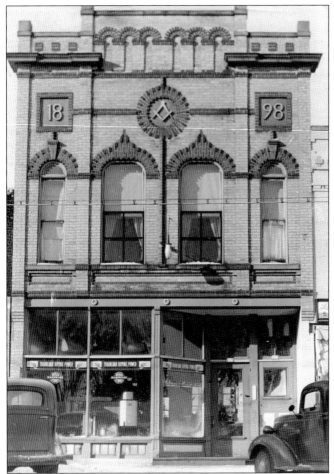

The Masonic Lodge is the longest ongoing organization in Oregon and was chartered in 1866. The first temple was above a store on South Main Street, then upstairs of the Netherwood Hall Building, which burned in 1896. In 1898, the lodge occupied the upstairs of the Marvin Hardware Store. In 1961, the lodge erected a new building at the corner of Spring and Park Streets.

The Masonic group gathered on January 18, 1935, to honor Charles W. Netherwood on his 70th anniversary as a Mason. He is sitting in the center.

The Order of the Eastern Star is an affiliate organization of the Masons. The group organized shortly after the Masonic Lodge was chartered in 1866. It is a Freemason organization with stated goals of charity, fraternity, education, and science. Both men and women can join. Pictured above are, from left to right, (first row) Luella Ames, Gus Hansen, Ada Dvergedal, Arthur Ames, and Marie Nelson (second row) Irene Wheeler, unidentified, Alta Jensen, Marian Owen, Mona Paulson, and Eeda Lumley; (third row) three unidentified, Florice Paulson, and three unidentified persons. The photograph shown below is one of Eastern Star officers.

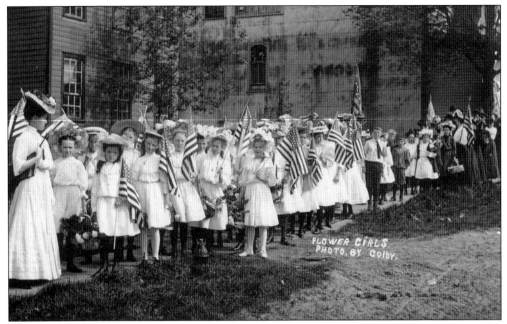

The Woman's Relief Corps (WRC) was organized in 1893 with Stella Graves as president. The group was very active in Oregon until after World War I. Members maintained the graves of veterans and recruited children from the village for the annual parade on Memorial Day.

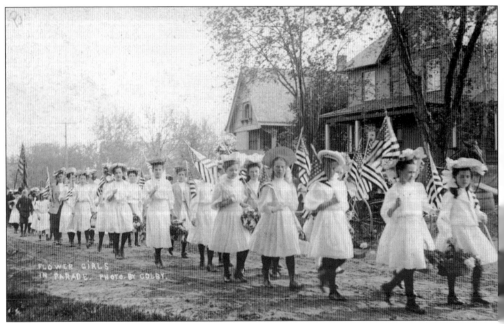

On Memorial Day, a well-known speaker was hired and always spoke to a large crowd at Cronk's Opera House. Carrying flags and bouquets to put on the graves, children marched from the opera house to the cemetery.

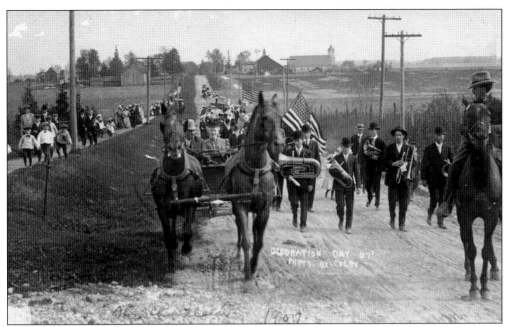

Oregon residents are heading to the cemetery on Memorial Day in 1907. Edward and Mary Chandler are riding in the buggy. The water tower is seen in the far background, and the 1885 Catholic church is visible.

The Modern Woodmen fraternal group was organized in 1891 and had 200 members. Its purpose was to provide insurance support. Drill teams were part of this organization. This group is gathered on the corner of Lincoln and Market Streets. Pictured are, from left to right, (first row) Capt. Dan Benson, Otto Litzkow, M.J. Wischoff, Peter C. Christensen, P.H. Dvergedal, Herb Hawley, Gene Garvoille, Frank Showers, E.H. Jaffrey, and Leonard Hobbs; (second row) C.E. Pledger Sr., Henry Dreher, Owen Clemans, E.F. Gallagher, Jake Starry, Ernie Culb, Chris Olson, and Edwin Olson.

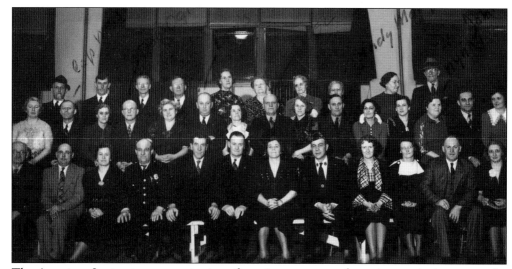

The American Legion is an organization of wartime veterans advocating patriotism across the United States. Pictured are, from left to right, (first row) William Bossingham, unidentified, Wilmay Morgan, George Johnson, George Harris, Ted Elliott, Gladys Elliott, Ivan Rasmussen, Dede Herrick, Minnie Peterson, Elmer Peterson, and Ruth Ames; (second row) Marcella Meister, Casper "Cap" Meister, Ann Ogilvie, William Ogilvie, Rachael Pease, Louis Pease, Irene Zink, Axel Johnson, Mabel Albers, Andrew Morgan, Ted Minch, Myrtle Rasmussen, Nyna Johnson, Clarence Bonsack, and Myrtle Bonsack; (third row) Norton Ames, George Albers, Ed Buche, Phil Kelley, May Harris, Elizabeth Kleppe, Alta Buche, Hilda Bossingham, Sally Kelley, and unidentified.

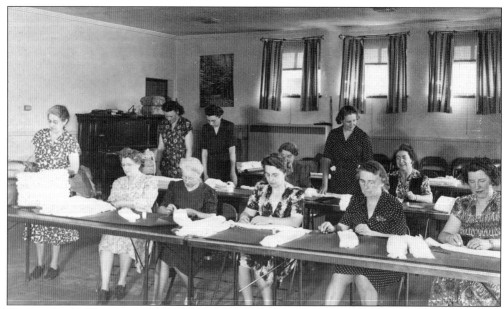

During World War II, an Oregon women's group helped the Allied war effort through civic activities such as preparing bandages for troops overseas. American women played important roles in World War II, both at home and in uniform.

Music has always been a part of the Oregon community and the schools. In 1882, the first band was organized in the village, and it provided concerts in the Waterman/Triangle Park on Wednesday and Saturday nights. The stores were open, and everyone came into town to shop and socialize.

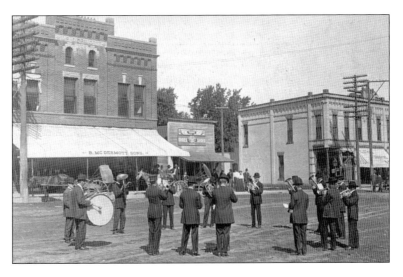

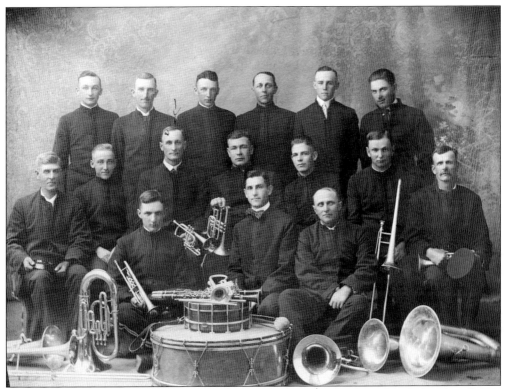

This Oregon Cornet Band was photographed on September 4, 1917, and includes, from left to right, (first row) Dallas Lamont, William Dunn, and Fred Luchsinger; (second row) Harry Taylor, Thoral Therkelson, H.W. Clapp, Ralph Balliette (director), Raymond Comstock, Louis Pease, and George Theobald; (third row) Morris Jackson, Harry Dreher, Lyman Jackson, Ira Johnson, Burr McWilliams, and Clayton Buskirk.

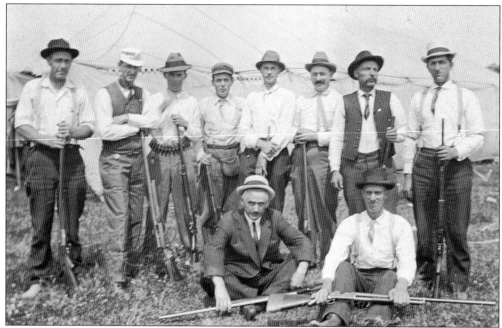

The Oregon Gun Club retained the Criddle Sliver Cup as a result of defeating the Stoughton Gun Club twice at clay pigeon shoots held in August 1913. Oregon shooters having the highest scores (41–44 hits out of 50 shots) were Dell, Therkelsen, McCormick, Cusick, Miller, Chappel, and W.H. Dreher. Some members of the Oregon Gun Club are shown in this photograph.

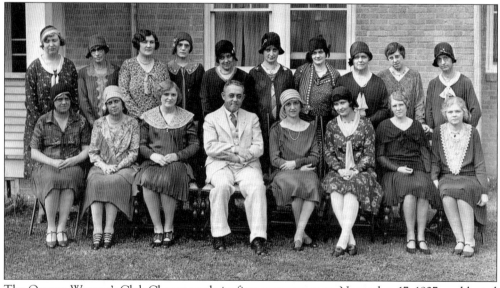

The Oregon Woman's Club Chorus made its first appearance on November 17, 1927, and lasted for about 10 years. Donald McGill was the director and accompanist. Several concerts were given for the general public with no admission charge. The group also made several radio broadcasts. Seen here are, from left to right, (first row) Esther McMannes, Helen Schuster, Ida Elliott, Donald McGill, Clarabelle Stone, Myrtle Bonsack, Alice Booth, and Lila Johnson; (second row) Marcella Meister, Eleanor Barry, Ada Dvergedal, Josephine Johnson, Louva Sweeney, Luella Ames, Eleda Frye, Minnie Litel, Myrtle Shilton, and Marie Richards.

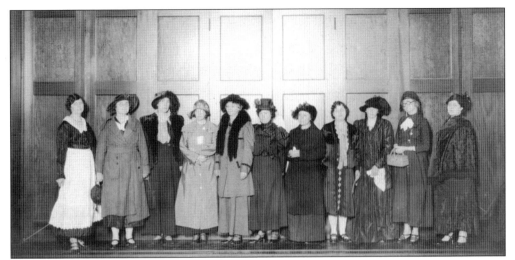

The Oregon Woman's Club also presented plays. Members seen here include, from left to right, Elizabeth McDermott, Mona Paulson, Mable Litch, Alice Booth, Lila Johnson, Bessie Killerlain, Mattie Mahaffey, Hattie Booth, Ruth Ames, Alta Buche, and Louva Sweeney.

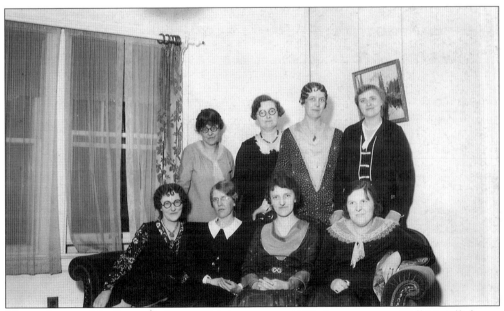

This gathering of the Junior Endeavor Club is at an annual Christmas party at Nell McGill's house on Friday, January 2, 1931. From left to right are (seated) Elsie Pease, Alice Booth, Bernice Hanan, and Nyna Johnson; (standing) Nell McGill, Mona Paulson, Veve Dunn, and Ida Elliott.

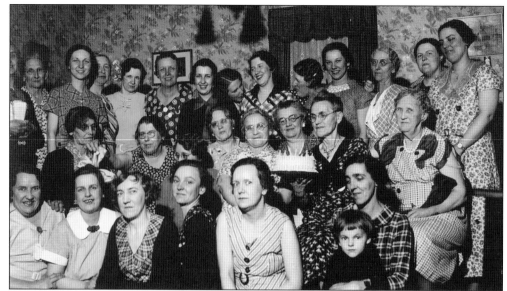

The South Side Birthday Club was started by Nell McGill and Genevieve "Veve" Dunn in the 1930s. The club met on this occasion in the 1930s to celebrate a birthday. Seen here are, from left to right, (first row) Beulah Therkelson, Veronica Barry, Ethel Shampnor, Gwendolyn Shinnick, Pansy Sholts, and Blanche Shinnick holding Winifred Shinnick; (second row) Henrietta Landers, Nealie DeJean, Nell McGill, Alta Buche, Emma Ringhand, Mae Prichard, and Dell Shampnor; (third row) Blanche Anderson, Mary Ann Olson, Marian Owen, Marcella Meister, Mary Peterson, Veve Dunn, Vivian Starry, Emma Madsen, Ethel Wischoff, Violet Owen, Margaret Criddle, Nyna Johnson, Marvel Otteson, and Anna Lavin.

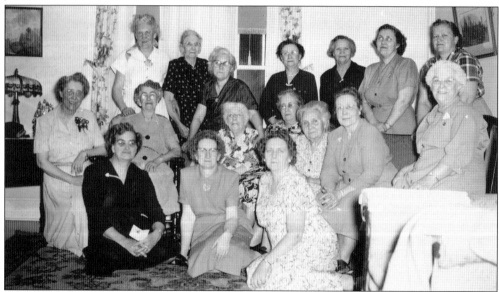

This birthday club gathering is at the McGill house on Washington Street. Pictured are, from left to right, (first row) Liz Spink, Verdie Powers, and Emma Madsen; (second row) Nell McGill, Katie Kelly, Edith Culp, Ann Schuler, Fannie Taylor, Mattie Mahaffey, and Hilda Hooper; (third row) Marie McGill, Mary Olson, Jessie Newton, Celia McMicken, Nettie Crotty, Fayette Inslee, and Dorothy White.

Nine

MILITARY

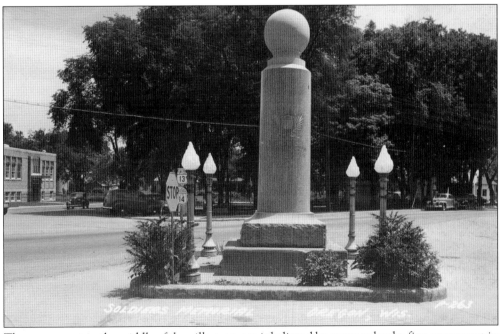

The monument in the middle of the village square is believed by many to be the first monument in the United States dedicated to the veterans of World War I. Today, it is dedicated to the veterans of all wars. This early view has the monument surrounded by four candle-shaped lamps.

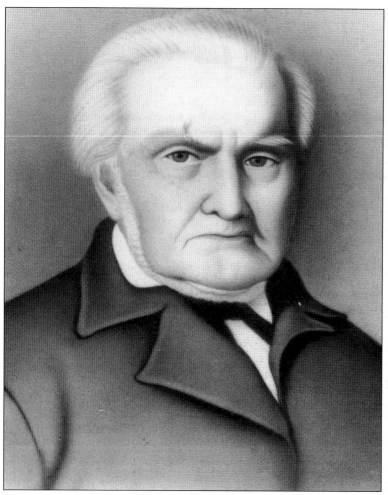

Nathaniel Ames (1761–1863) was the last Revolutionary War veteran in Wisconsin. He enlisted in the Continental army and was stationed at Valley Forge in the winter of 1779–1780. At the age of 84, he moved to a house in the town of Oregon (see photograph below) where he lived and farmed until 1861, when he moved to the village. Ames died at age 102 and is buried at Prairie Mound Cemetery in Oregon. In 1955, the Dane County chapter of the Sons of the American Revolution was chartered as the Nathaniel Ames Chapter.

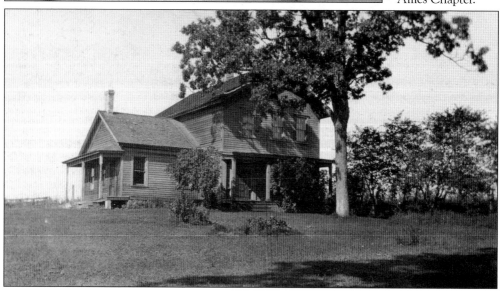

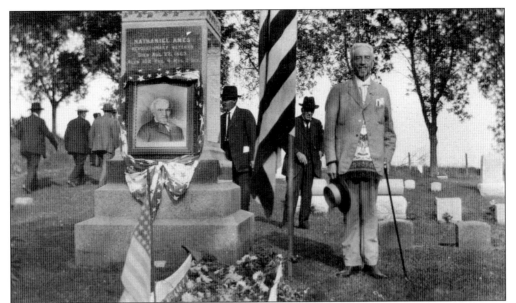

The 60th anniversary of the death of Nathaniel Ames was commemorated on August 30, 1923, by local area Masons at Prairie Mound Cemetery in Oregon. The program included reminiscences of John H. Corscot, who shared his experience of having attended the Masonic Rites at Ames's funeral 60 years earlier.

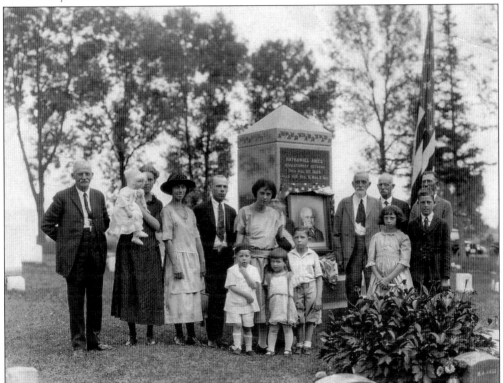

The Ames family gathered to honor their ancestor Nathaniel Ames at the Masonic commemoration. (Courtesy of Jack O'Keefe.)

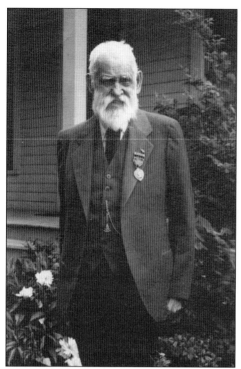

Charles Netherwood (1843–1938) was born in Watervliet, New York, the son of Joseph and Emma Netherwood. His family moved to the town of Oregon when he was a young boy. On August 30, 1862, he enlisted for military service, serving with Company E, 23rd Wisconsin Volunteer Infantry. Netherwood was wounded during the Siege of Vicksburg when a cannonball shattered his face. He was hospitalized in Memphis and was discharged on November 11, 1863. (Courtesy of Kay Curless Collins.)

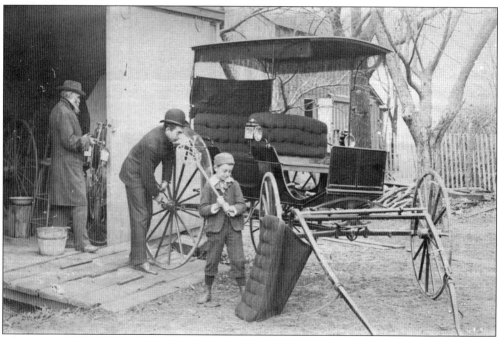

Returning to Oregon after the Civil War, Charles Netherwood became a prominent business and civic leader. Some of the many positions he held included town treasurer, village president, member of the local board of education, and village postmaster. This photograph, taken about 1894, shows three generations of the Netherwood family: Charles, his son Harry, and grandson Perry. (Courtesy of Kay Curless Collins.)

William Soden (1837–1917), at the outbreak of the Civil War, enlisted in the 23rd Wisconsin Infantry Regiment and fought throughout the Vicksburg Campaign. He was captured at the Battle of Sabine Cross Road in Louisiana and was held prisoner at Camp Ford, Texas. Soden was released from military duty in 1865 and, in 1880, returned to Oregon to settle. The photograph from 1916 shows William and his wife, Hattie, along with their children.

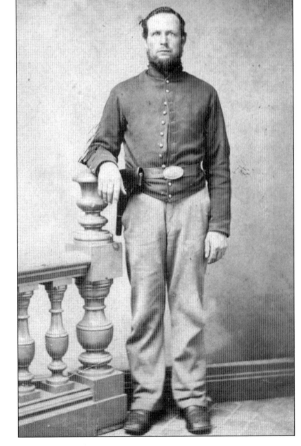

Lyman L. Hanan (1824–1885) was mustered into the Wisconsin 33rd Infantry on December 3, 1863, and transferred to the 11th Infantry, Company C. He served in Louisiana and Alabama and was part of the Mobile Campaign as well as the Battles of Spanish Fort and Fort Blakeley. Hanan was mustered out of the service on July 22, 1885, due to illness.

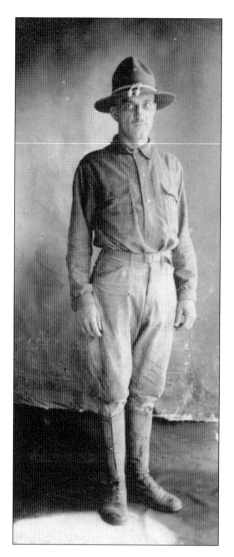

William Johnson (1890–1918) was born in Oregon to Christopher and Cecelia Johnson and was the only Oregon serviceman who did not return from World War I. He enlisted in the service on May 26, 1918, as a private in Company L, 354th Infantry and was killed in action on November 4, 1918, while serving with the American Expeditionary Forces in the Battle of Meuse River in France. He was honored by the Oregon American Legion Post, which was named after him. Johnson is buried at the Meuse-Argonne American Cemetery in Romagne-sous-Montfaucon, France.

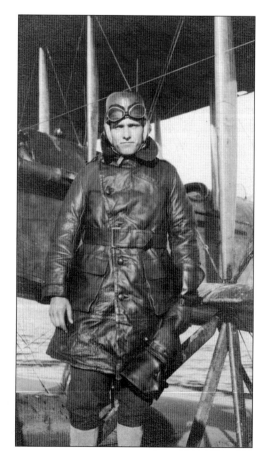

Norton Travis Ames (1895–1961) was a local resident who served during World War I with the 1st Marine Aeronautic Company, Advance Base Force, US Marine Corps. He enlisted August 28, 1917, and flew submarine patrols from Pont Delgado in the Azores islands. This was the first Marine Aviation unit to be deployed during World War I.

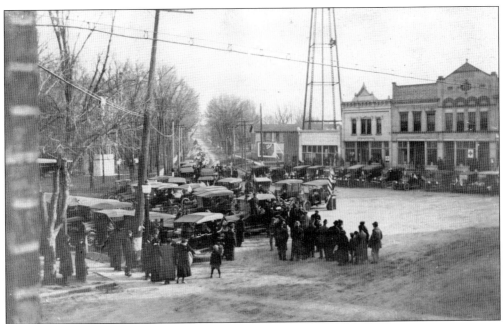

The declaration of an armistice on November 11, 1918, ending World War I called for a celebration. Every available bell was rung and every whistle was blown following the announcement of the joyous event. One of the first alarms in the village was the ringing of the Methodist church bell by W.L. Ames. A half-holiday was declared as businesses closed, and people joined a parade through the village. G.L. Booth sat on the water tower ringing the fire bell for hours on end.

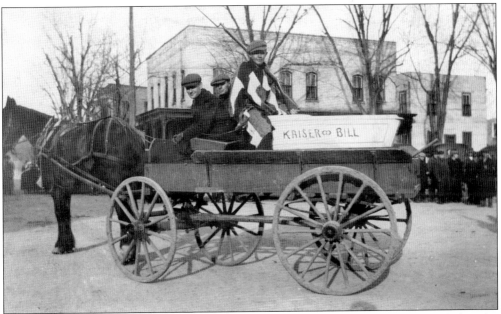

The parade started at the schoolhouse, wound its way through the village, and ended in the village square, where the celebration continued with music by the band, singing and shouts from the crowd, and the disposing of an effigy of "Kaiser Bill." Short addresses were given by Rev. F.E. Wagg and A.H. Sholts.

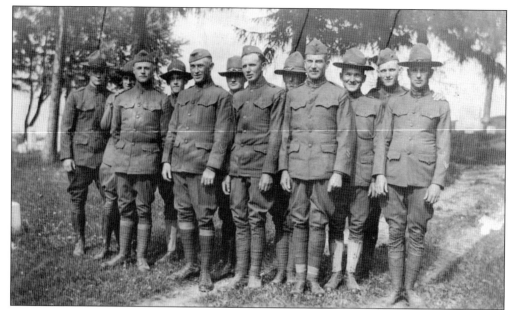

A total of 86 men from the Oregon area served in World War I. Local area troops made their way home following the war. Glad to be back, a group of Oregon veterans gathered for a photograph. Among those pictured here are Ted Elliot, George White, Norton Ames, Elmer Peterson, and Earl H. Sholts.

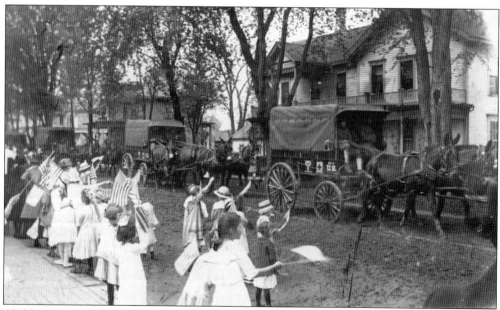

Children cheer and wave flags as a troop train makes its way through the village. Young people would remember this day in years to come, as it was the custom on November 11, at 11:00 a.m. for all schoolchildren to rise, face the east, and place their right hands over their hearts for a moment of silence in remembrance of those who had fought for their country.

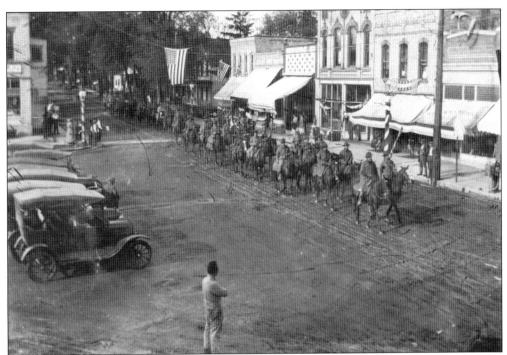

Beginning a few years before World War I and continuing until the late 1930s, cavalry soldiers stationed at Camp Grant, Illinois, passed through Oregon on their way to Camp Douglas, Wisconsin. Summer exercises were held there for two to three weeks, after which they came back through the village. On a few occasions, they camped on a field located near the intersection of Janesville and State Streets.

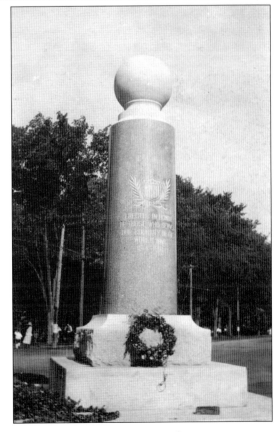

On June 10, 1920, a monument in the village square was dedicated to those who fought in World War I. It was unique in its construction, made from a granite shaft salvaged from the old Chicago City Hall. It arrived in Oregon by rail, was unloaded at the Jefferson Street viaduct, and was moved into place with the help of six teams of horses and many townsmen. Today, it remains a landmark in the village square dedicated to the veterans of all wars.

George H. Litch Jr. (1918–1945) was the son of George and Mabel Litch. He entered military service on July 21, 1944, serving in the Army's 376th Infantry. Stationed on the front lines beyond the German border, Litch was killed in action on January 28, 1945, in the Battle of the Bulge. He was buried at the American Cemetery in Luxembourg. In his honor, the local American Legion Post became the Johnson-Litch American Legion Post.

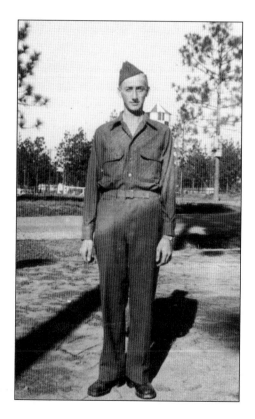

Donald E. Noyce (1920–1944) was the son of Joseph and Alma Noyce. He enlisted in the armed forces on September 14, 1942. Noyce served with the 112th Infantry, 28th Division in the European theater of operations. He was killed in action on August 9, 1944, and was buried in the Brittany American Cemetery at St. James, France.

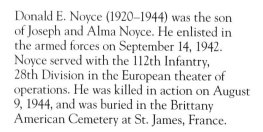

Leonard Sather (1914–1944) was the son of Marthinius and Magna Sather. He was inducted into the Army on April 16, 1941, and went on to serve in the South Pacific in the 128th Infantry, Company B, 32nd Division. He died of pneumonia on April 24, 1944, in Finchhaven, New Guinea. (Courtesy of Susan Sather and Robert Sather.)

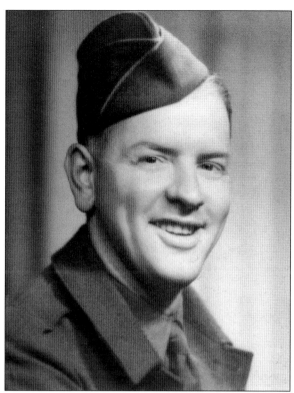

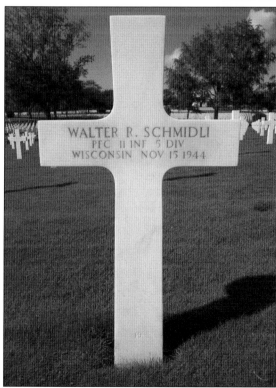

Walter Schmidli (1918–1944) was the son of Conrad and Emma Schmidli. He enlisted in the Army on November 7, 1941, and served in Company F, 11th Infantry Regiment, 5th US Army Division and served in the European theater of operations. Schmidli was killed November 15, 1944, in Metz, Germany, just two weeks after he returned to the front lines. He is buried at the Lorraine American Cemetery in St. Avold, France. (Courtesy of the American Battle Monuments Commission.)

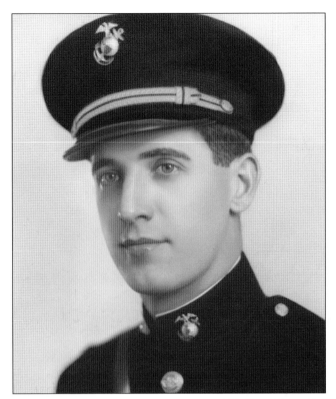

Robert J. Sweeney (1919–1942) was the son of Thomas J. and Winnie (Shannon) Sweeney. He served in the South Pacific theater of World War II as a second lieutenant in the US Marine Corps. Sweeney was killed in action on August 8, 1942, at the Guadalcanal/Solomon Islands operations. His remains were returned to Oregon in March 1948 and buried in St. Mary's Cemetery.

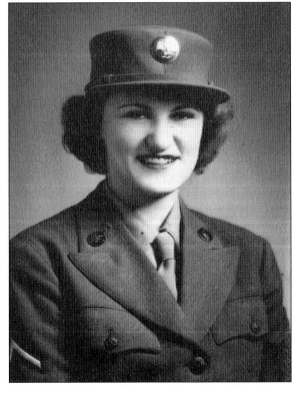

Eunice H. Onsrud, daughter of John Sr. and Esther Onsrud, served in World War II in the Women's Army Corps (WACS) as a tech 3 assigned to the Fifth Army in Italy. She, along with her platoon, was selected to be part of the honor guard for Winston Churchill and King George VI of England. Onsrud received the Fifth Army plaque and clasp for outstanding service. Other women in the Oregon area who served in World War II include Lucy Wallace, Rita Plummer, Fern Klug, Camilla Schloemer, and Joy (Fitzgerald) Hulburt. (Courtesy of Naomi Onsrud Rockwell and John Onsrud.)

Ten

NOTABLE PEOPLE, PLACES, AND EVENTS

The Wisconsin School for Girls had its beginnings as the Milwaukee Industrial School, an institution for the care of delinquent and orphaned girls and very young boys. It operated as a private institution, with the government providing taxpayer support in 1876. In 1941, the school moved to Oregon and became the Oregon School for Girls. It became a coeducational juvenile reformatory in 1972 and, four years later, became the Oakhill Correctional Institution.

The Lincoln Street Historic District in Oregon contains a collection of five single-family homes dated from around 1870 to 1894. West Lincoln Street was formerly known as Third Street in 1863 and lies within the Johnson Addition to the village of Oregon, a part of Stoddard Johnson's 40-acre farm.

Henry Algard came to the township of Oregon in 1846 with his parents, Joseph and Eliza Algard. Henry was the blacksmith in Storeytown and served as one of the supervisors of the township for four terms. The home on Lincoln Street was built around 1890 by Henry and Phoebe Algard, who owned it until 1906. Henry and George Algard were said to have the first automobile in Oregon. A carriage house is located at the rear of the property.

One of the older homes in Oregon is a Queen Anne–style house built in 1897 for L.B. Marvin, the eldest son of local hardware merchant H.H. Marvin. At the time, the house was called one of the finest in town. The Marvins lived there until 1901 and then traded it for one owned by M.R. Terwilliger. The home is located at 248 North Main Street.

This home was built for John and Flora Gilbert, and from the time construction began on the house at 357 North Main Street, it soon became known that this house would be something special. An impressive wraparound veranda adds charm to the home. When the house was finished in 1907, the *Oregon Observer* claimed, "It is a beautiful home and has all the modern improvements. It is the most expensive dwelling in town."

This photograph was taken in December 1929. Shown are, from left to right, Elizabeth, Milton, and Ethel Wischhoff. Newlyweds Milton and Ethel were married in September 1929. Milton operated a jewelry store for 51 years until he retired in 1965.

Edwin A. Kozlovsky, familiarly known as "Koz" or "Mr. K," served as teacher, principal, and superintendent in the Oregon School District over a span of 41 years. Upon graduation from Carroll College, he joined the teaching staff in 1927 as a science teacher and coach of basketball, baseball, and track. He was affiliated with several educational associations as well as being a member of the Oregon Rotary Club and the Oregon Chamber of Commerce.

Owen E. "Ole" Richards started a banking career in 1903 that would last his lifetime. He was 14 when he took a job at the bank working for no pay for the first month and only $10 for the second month. Throughout his banking career, Richards was active in many banking organizations but also found time to be active in many civic organizations in Oregon. He is shown here making his daily trip to the depot.

Mary Brabyn (shown here) and Charles Wackman were married in 1893. Charles was a retail merchant operating a clothing store named Powers & Wackman. Mary was an acclaimed poet. She had three books of her poems published and appeared before many groups, reading her poems. Their daughter Charline graduated from the University of Wisconsin and the Columbia College of Expression in Chicago. She played on the professional stage and taught dramatics.

Egbert Bennett was born in 1819 in Albany, New York, and came to the Oregon area in 1846. He built a home on 10 acres of land in the center of town. Pres. Franklin Pierce appointed him as the first postmaster of Oregon in 1848. Bennett sold his original acres in the village in 1856 and purchased a farm on Rutland-Dunn Townline Road. Bennett is shown here with his great-grandchildren.

Ruth Ames was elected to the Oregon School Board in 1935, serving as clerk for 32 years. Upon her retirement in 1967, a luncheon was held in her honor, where Ames was given the title of "Oregon's First Lady". During her tenure, she was the only woman on the board. Her time on the board saw the school district expand from 330 students to 2,114 and a teaching staff of 12 to 97.

The Steinhauer sisters grew up singing on their front porch after their chores were finished. All were very good yodelers, performing at horse shows and church picnics, and winning home talent shows. They auditioned and sang on the WLS radio show in Chicago. Youngest sister Teresa passed away at a young age. Ellen (Johnson) dropped out of the group when she married, but Dorothy (Freitag) and Ann (Bossingham) continued to sing at various events. Pictured are, from left to right, (first row) Teresa and Ann; (second row) Dorothy and Ellen.

This unique photograph is of Pearl Johnson and Mona Paulson (mother of Florice Paulson). Mona graduated from Oregon High School in 1906 and married Arthur Paulson in 1910. She served on the Oregon Library Board for 53 years and was a longtime member of the Oregon Eastern Star, a member of the Oregon Woman's Club, and many other civic organizations. She owned and operated a shop from 1948 to 1956. Mona Paulson died in 1985.

Florice Paulson was serious about her 25-year teaching career, but this photograph shows that she also enjoyed time away from her classroom. As a fifth-generation resident of Oregon, Paulson had a love of history that led her to write a weekly history column for the local newspaper titled A Walk Back in History: Did You Know? Florice purchased and donated a building to be used as a local museum for the Oregon area.

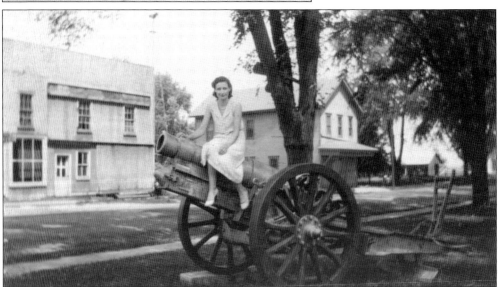

Merle Dale sits atop the cannon in this photograph taken in 1932. The cannon is located in the Waterman Park. It is a field gun built in 1918 and dedicated by VFW Post 9379. The World War I cannon was sent for the scrap metal drive in World War II and later replaced with a World War II cannon.

Charles Waterman was born in 1822 in Orleans County, Vermont, and came to Oregon in 1849 and bought a 200-acre farm. In 1858, he opened and owned the Oregon Exchange Hotel for two years. Waterman went into the mercantile business and later became a contractor grading the Chicago & North Western Railroad. He began a livery business in 1874 and operated it until 1880, when he sold it to Powers & Fisher.

This photograph is of the funeral procession for Roy C. Richards in 1915. He died tragically in a train accident at age 37. The horse-drawn hearse shown coming up from South Main Street is sided with glass exposing the coffin. Richards was born in September 1877. He was a stock buyer and prominent business owner with Everett Graves and Owen Roberts.

Oregon held a fall festival in September 1932. Festivities began at 9:00 a.m. with a children's parade followed by a parade of decorated floats and bands. Other events included pony races, baseball games, a tug-of-war, bronco riding, a water fight, free movies, and dances. Another amusing and exciting event at the festival was catching the greased pig. A band concert was held in the village park with bands from Oregon, McFarland, and Verona and a clown band. Baseball games brought friendly rivalry between teams from New Glarus and Albany and those from Oregon. Shown on the float is Clarice Quale, the festival queen in 1933. Attendants are Mary Ann Manion and Catherine Clark.

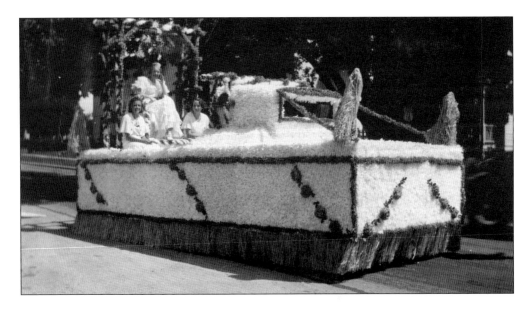

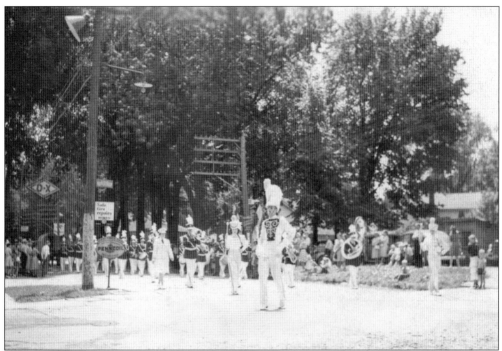

Festivities for Oregon's centennial celebration took place July 4, 5, and 6 in 1941. It was held in conjunction with the regular Oregon Festival and the dedication of the new village hall. Many months of planning went into celebrating this significant milestone of Oregon's history. "The Centennial Cavalcade on Oregon's Trails" pageant featured a huge cast of Oregon residents, reenacting scenes from the past 100 years. An estimated 10,000 people viewed the centennial's parade. It featured nearly 100 entries consisting of many floats, bands, horse-and-buggy units, a special team of oxen, and covered wagon. Reminders of Oregon's pioneer days were on display in store windows. Local churches served meals in the community hall during the three days of the celebration.

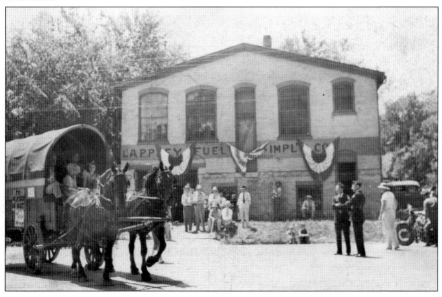

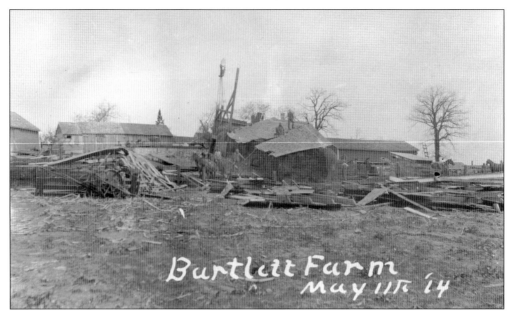

A destructive tornado hit Oregon on May 11, 1914. Damage was widespread, and many farms suffered damage. A three-year-old child, Lyman Frederickson, son of Bernhardt Frederickson, died on the Bartlett farm located one mile west of the village. Many animals were lost as well. Neighbors from all around worked night and day to help clean up the path of destruction.

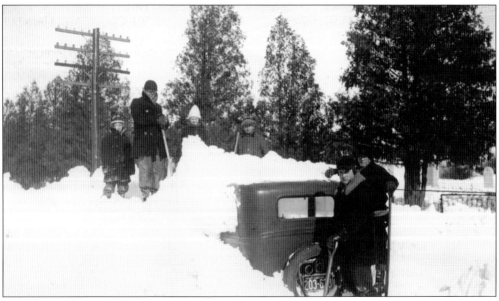

In February 1936, Wisconsin experienced the coldest and snowiest February on record. High winds caused severe drifting, blocking highways and railways. Some drifts were more than 10 feet deep. Two major snowstorms caused schools to be closed for two weeks. Here, in Oregon, Gene Berman's car is almost completely covered near the Catholic cemetery. The child in the white stocking cap is Virginia Johnson.

BIBLIOGRAPHY

Ames, William. *History of Oregon*. Oregon, WI: n.p., 1924.

Clayton, Lee and John W. Attig. *Pleistocene Geology of Dane County, Wisconsin*. Madison, WI: University of Wisconsin-Extension, Wisconsin Geological and Natural History Survey, 1997.

Kinney, Thomas P. *Irish Settlers of Fitchburg, Wisconsin, 1840–1860*. Fitchburg, WI: Fitchburg Historical Society, 1993.

Larsen, Richard N. *Oregon Wisconsin and the Civil War (1861–1866), Part One: The Men*. Oregon, WI: Oregon Area Historical Society, 2006.

Mickelson, David M. *Landscapes of Dane County, Wisconsin*. Madison, WI: Wisconsin Geological and Natural History Survey, Educ. Series 43/2007, 2007.

Oregon Observer. Centennial editions, 1941.

Oregon, Wisconsin Sesquicentennial. Oregon, WI: Town of Oregon, 1991.

Paulson, Florice. *A Walk Back In History: Did you Know?* Oregon, WI: Oregon Area Historical Society, 1991.

Paulson, Florice. *Oregon School District, Rural and Village Schools, 1846–1998 "From Immigrant to Internet."* Oregon, WI: Oregon Area Historical Society, 1998.

RutlandChurch.org.

Souvenir Book Committee (Dr. W.E. Ogilvie, chairman). *History of the Community's Progress*. Oregon, WI: Souvenir of Oregon Centennial, 1941.

VFW Post No. 9379 (compiled for). *Service Record for World War II, Oregon and Community*. n.d.

Western Publishing Company. *1880 History of Dane County*.

Discover Thousands of Local History Books Featuring Millions of Vintage Images

Arcadia Publishing, the leading local history publisher in the United States, is committed to making history accessible and meaningful through publishing books that celebrate and preserve the heritage of America's people and places.

Find more books like this at
www.arcadiapublishing.com

Search for your hometown history, your old stomping grounds, and even your favorite sports team.

Consistent with our mission to preserve history on a local level, this book was printed in South Carolina on American-made paper and manufactured entirely in the United States. Products carrying the accredited Forest Stewardship Council (FSC) label are printed on 100 percent FSC-certified paper.

MADE IN THE